Carsten
Höller
Test
Site
Source
Book

Unilever

The Unilever Series
An annual art commission
sponsored by Unilever

Published by order of the Tate Trustees
on the occasion of the exhibition at Tate Modern, London
10 October 2006 – 9 April 2007

This exhibition is the seventh commission in
The Unilever Series

26/1/07

Published in 2006 by Tate Publishing,
a division of Tate Enterprises Ltd,
Millbank, London SW1P 4RG
www.tate.org.uk/publishing

© Tate 2006

British Library Cataloguing in Publication Data
A catalogue record for this publication is available from
the British Library

ISBN-13: 978-185437-744-9
ISBN-10: 1-85437-744-2

Designed by Cartlidge Levene
Printed and bound in Great Britain by
Balding + Mansell, Norwich

Contents

I have chosen the texts and images in this book for their correlation to the structure of the slide (curvilinear, no off-shoots) and to the condition of the person sliding. Predominantly from my own library, these are passages and illustrations that have been my companions in the past or that appeared in a new light in this context. None of the excerpts is unduly extensive; we haven't reprinted entire books so that the individual chapters are not so disparate that the regular rhythm of the recurrently new is lost. For this sequence of texts is also about repetition (of the recurrently new), and the whole book should be readable as a text in its own right.

Amongst the very earliest selections were three works that were not used at all in the end because they were too long. Excerpts from these would, by definition, only have contradicted the nature of these books. They only exist in their entirety: Soren Kierkegaard's Repetition, Virginia Wolff's To the Lighthouse and Alain Robbe-Grillet's Repetition. When I read these books I felt as though I were shooting down a helter-skelter, while gazing at a twisting slide.

The works that have been included here are less obviously connected with slides than those first three – having been written after rather than in the process of sliding; they originated in a time when the widespread use of slides had led to a change that is reflected in these texts and images. Since this time is still up ahead of us all we can say now is that there may be a lot more to come that we know little of as yet. I feel that the frequent use of slides leads to a particular form of change. The works in this book convey a sense of this change, as I see it. This is how I imagine the change but I could be on the wrong track here.

If I am wrong and the change turns out to be not as I imagine it, or there isn't any change at all, these are still good texts that deserve to be here. They would then simply stand as descriptions or structural affinities to the slide, like the books mentioned above; they supply words and images for the almost unspeakable moment of sliding – what Roger Caillois has attempted to define in his theory of vertigo as 'an attempt to

momentarily destroy the stability of perception and inflict a
kind of voluptuous panic upon an otherwise lucid mind'.
Apart from the potential for change, my other arguments for
the use of slides as worthy (albeit exclusively downwards)
equivalents to stairs, escalators and lifts are that slides, as a
mode of transport, deliver people quickly, safely and elegantly
to their destinations, they are inexpensive to construct and
energy-efficient. So we commissioned Foreign Office Architects
to design a twenty-three storey model building using slides
in the construction and as the main mode of transport for
travelling downwards (see the book Test Site, published
concurrently with this volume) – a building where slides are
part of the external framework of the construction. Partly
because the slides have to be densely packed together in the
lower section of a building of this nature, and partly in order
to create direct connections to the centre of the building,
the architects came up with the 'Hypothetical Slide House'
consisting of three columns leaning against each other to create
a three-footed structure with three arms stretching up into
the sky from a central belt. The hypothesis is that in the years
to come slides will be used as a means of transport and that,
consequently, houses will be built from slides. And these double
tripods could be interlocked to form a city rather like a forest
of mangroves.
 Apart from anything else, sliding induces a form of
delight that is reflected in the facial expression of those arriving
at the bottom of a slide. This delight is of course also the reason
why slides are found in playgrounds and at amusement parks.
In the Test Site book Roy Kozlowsky goes into the history of
the slide and, with a sideways glance at Sigmund Freud, asks 'Is
the slide an expression of overcoming fear, or rather the deadly
flirtation with self-destruction?' As General Public Agency
suggest in the book, this uplifting effect could possibly be used
to reduce stress and to overcome low spirits or anxiety. And, as
far as the other arguments are concerned, GPA presents us
with examples for the possible ubiquity of the slide. The Test
Site book is an extended plea for the much wider use of the

slide, and Dorothea von Hantelmann's essay on sliding as a
Nietzschean method to 'stretch the boundaries of the I, of
the body and of one's own ontological consistency' adds a
psychoanalytical and philosophical dimension to this plea.
She explores the potential for change associated with the slide.

There is no reason why slides should only be found
in children's playgrounds and as emergency chutes. The
installation in the Turbine Hall at Tate Modern is a public
experiment designed as an investigation into the way that slides
are received and what effect they have on users and viewers
– a Test Site, a feasibility study using volunteers in a museum
space. Under scrutiny is people's response to the slides, their
behaviour when they are using the slides, the level of danger,
mood-changing effects, the potential for more radical change
– and what it really means to slide. The tests are conducted by
the users, there is no 'objective' authority taking measurements.
If the test results are favourable the slide should start to
proliferate across the city; it should find its way into existing
buildings and into architectural plans still on the drawing board.
But the site of the test is not only the Turbine Hall; it is also that
little part in the user and viewer that is stimulated by the slide: a
site within.

In this source book we have included illustrations of
Trajan's Column in Rome and Brancusi's Endless Column,
in order to counteract the possible misconception that using
the slides is a necessary part of the reception of the work.
Beholding the work is a different, equally valid experience.
The beholders are not somehow excluded (too fearful, too
small, too fragile, wrongly dressed, fearing public exposure).
After all they are viewing a sculpture just as one might
contemplate the Endless Column – a sculpture that takes
people inside and only releases them at the deepest recesses,
like a huge nervous system through which messages are
transmitted at top speed in order to set the body in motion.

My thanks go first and foremost to Jessica Morgan
for her tireless commitment as curator of this project. She has
given me the greatest imaginable support. In addition I should

like to thank the following at Tate Modern: Vincent Honoré in his role as assistant curator, Stephen Mellor for technical support, Sheena Wagstaff for her valuable suggestions, Vicente Todoli for the green light, Nicholas Serota for his enthusiasm. I am also sincerely grateful to Phil Monk as Technical Director, Dennis Ahern for dealing with the German TÜV (Technical Monitoring Association), and all those staffing and seeing to the smooth running of the slides. Finally, I should like to express my gratitude for the trust that Tate Modern has put in me.

None of this would have been possible without the generous support of the sponsors of this project. I owe a deep debt of gratitude to Unilever and in particular to Patrick Cescau and Gavin Neath. Amongst the staff at the firm of Wiegand in Rasdorf (in Hessen, Germany), I am especially indebted to Wolfgang Hinze; he has achieved the impossible. I hope that he can enjoy the five London slides as the grand finale of his career. My thanks also go to Doreen Fischer for her numerous drawings and to the construction team led by Michael Kretschmer, who installed the slides with the help of Jens Höhne, Tobias Ritter and Stefan Sauer; to Stefan Eberhardt, the lead structural engineer; to Wolfgang Ritz who supervised safety issues; to Walter Krol and his team who produced the stainless steel; to Hans-Jürgen Römhild and Michael Kretschmer who managed the production process.

I should like to express particular thanks to Farshid Moussavi of Foreign Office Architects, Clare Cumberlidge, David Knight and Lucy Musgrave of GPA, Roy Kozlowsky, Dorothea von Hantelmann and Jessica Morgan for their excellent contributions to the 'Plea for Slides' in the book Test Site. In the selection of texts for the Test Site: Source Book I greatly profited from the expertise of my advisors Daniel Birnbaum, Anders Kreuger, and Hans Ulrich Obrist.

For conversations and discussions that contributed in one way or another to Test Site my thanks go to Miriam Bäckström, Philippe Parreno, Sven-Olof Wallenstein, Jennifer Allen, Esther Schipper, Marcel Odenbach, Jan Åman, Mark Francis, Christophe Wiesner and, not least, Klaus Biesenbach,

who suggested in the first place that I should make a slide in the Kunstwerke for the first Berlin Biennial (that one slide then became two).

Concurrently with our work on the slides, we also developed another, untitled project that went as far as the testing phase in the Turbine Hall. This project was managed by Uwe Schwarzer and his colleague Christian Skolud. Even although we decided in the end to concentrate solely on the slides, I should nevertheless like to thank both of them for their efforts. They were also involved in the lighting for Test Site.

My final thanks go to the galleries: Esther Schipper in Berlin, Gagosian Gallery in London, and Air de Paris in Paris.

Carsten Höller

Essays
Writings

H.G. Wells

Certainly, if ever a man found a guinea when he was looking
for a pin it is my good friend Professor Gibberne. I have heard
before of investigators overshooting the mark, but never quite
to the extent that he has done. He has really, this time at any
rate, without any touch of exaggeration in the phrase, found
something to revolutionise human life. And that when he was
simply seeking an all-round nervous stimulant to bring languid
people up to the stresses of these pushful days. I have tasted the
stuff now several times, and I cannot do better than describe
the effect the thing had on me. That there are astonishing
experiences in store for all in search of new sensations will
become apparent enough.

Professor Gibberne, as many people know, is my
neighbour in Folkestone. Unless my memory plays me a
trick, his portrait at various ages has already appeared in *The
Strand Magazine* – I think late in 1899; but I am unable to
look it up because I have lent that volume to someone who has
never sent it back. The reader may, perhaps, recall the high
forehead and the singularly long black eyebrows that give such
a Mephistophelian touch to his face. He occupies one of those
pleasant detached houses in the mixed style that make the
western end of the Upper Sandgate Road so interesting. His is
the one with the Flemish gables and the Moorish portico, and
it is in the little room with the mullioned bay window that he
works when he is down here, and in which of an evening we
have so often smoked and talked together. He is a mighty jester,
but, besides, he likes to talk to me about his work; he is one of
those men who find a help and stimulus in talking, and so I
have been able to follow the conception of the New Accelerator
right up from a very early stage. Of course, the greater portion
of his experimental work is not done in Folkestone, but in
Gower Street, in the fine new laboratory next to the hospital
that he has been the first to use.

As everyone knows, or at least as all intelligent people
know, the special department in which Gibberne has gained
so great and deserved a reputation among physiologists is the
action of drugs upon the nervous system. Upon soporifics,

sedatives, and anaesthetics he is, I am told, unequalled. He is also a chemist of considerable eminence, and I suppose in the subtle and complex jungle of riddles that centres about the ganglion cell and the axis fibre there are little cleared places of his making, glades of illumination, that, until he sees fit to publish his results, are inaccessible to every other living man. And in the last few years he has been particularly assiduous upon this question of nervous stimulants, and already, before the discovery of the New Accelerator, very successful with them. Medical science has to thank him for at least three distinct and absolutely safe invigorators of unrivalled value to practising men. In cases of exhaustion the preparation known as Gibberne's B Syrup has, I suppose, saved more lives already than any lifeboat round the coast.

'But none of these things begin to satisfy me yet,' he told me nearly a year ago. 'Either they increase the central energy without affecting the nerves or they simply increase the available energy by lowering the nervous conductivity; and all of them are unequal and local in their operation. One wakes up the heart and viscera and leaves the brain stupefied, one gets at the brain champagne fashion and does nothing good for the solar plexus, and what I want – and what, if it's an earthly possibility, I mean to have – is a stimulant that stimulates all round, that wakes you up for a time from the crown of your head to the tip of your great toe, and makes you go two – or even three to everybody else's one. Eh? That's the thing I'm after.'

'It would tire a man,' I said.

'Not a doubt of it. And you'd eat double or treble – and all that. But just think what the thing would mean. Imagine yourself with a little phial like this' – he held up a bottle of green glass and marked his points with it – 'and in this precious phial is the power to think twice as fast, move twice as quickly, do twice as much work in a given time as you could otherwise do.'

'But is such a thing possible?'

'I believe so. If it isn't, I've wasted my time for a year. These various preparations of the hypophosphites, for example,

seem to show that something of the sort ... Even if it was only one and a half times as fast it would do.'

'It *would* do,' I said.

'If you were a statesman in a corner, for example, time rushing up against you, something urgent to be done, eh?'

'He could dose his private secretary,' I said.

'And gain – double time. And think if *you*, for example, wanted to finish a book.'

'Usually,' I said, 'I wish I'd never begun 'em.'

'"Or a doctor, driven to death, wants to sit down and think out a case. Or a barrister – or a man cramming for an examination.'

'Worth a guinea a drop,' said I, 'and more to men like that.'

'And in a duel, again,' said Gibberne, 'where it all depends on your quickness in pulling the trigger.'

'Or in fencing,' I echoed.

'You see,' said Gibberne, 'if I get it as an all-round thing it will really do you no harm at all – except perhaps to an infinitesimal degree it brings you nearer old age. You will just have lived twice to other people's once –'

'I suppose,' I meditated, 'in a duel – it would be fair?'

'That's a question for the seconds,' said Gibberne.

I harked back further. 'And you really think such a thing *is* possible?' I said.

'As possible,' said Gibberne, and glanced at something that went throbbing by the window, 'as a motor-bus. As a matter of fact –'

He paused and smiled at me deeply, and tapped slowly on the edge of his desk with the green phial. 'I think I know the stuff ... Already I've got something coming.' The nervous smile upon his face betrayed the gravity of his revelation. He rarely talked of his actual experimental work unless things were very near the end. 'And it may be, it may be – I shouldn't be surprised – it may even do the thing at a greater rate than twice.'

'It will be rather a big thing,' I hazarded.

'It will be, I think, rather a big thing.'

But I don't think he quite knew what a big thing it was to be, for all that.

I remember we had several talks about the stuff. 'The New Accelerator' he called it, and his tone about it grew more confident on each occasion. Sometimes he talked nervously of unexpected physiological results its use might have, and then he would get a little unhappy; at others he was frankly mercenary, and we debated long and anxiously how the preparation might be turned to commercial account. 'It's a good thing,' said Gibberne, 'a tremendous thing. I know I'm giving the world something, and I think it only reasonable we should expect the world to pay. The dignity of science is all very well, but I think somehow I must have the monopoly of the stuff for, say, ten years. I don't see why *all* the fun in life should go to the dealers in ham.'

My own interest in the coming drug certainly did not wane in the time. I have always had a queer little twist towards metaphysics in my mind. I have always been given to paradoxes about space and time, and it seemed to me that Gibberne was really preparing no less than the absolute acceleration of life. Suppose a man repeatedly dosed with such a preparation: he would live an active and record life indeed, but he would be an adult at eleven, middle-aged at twenty-five, and by thirty well on the road to senile decay. It seemed to me that so far Gibberne was only going to do for any one who took this drug exactly what Nature has done for the Jews and Orientals, who are men in their teens and aged by fifty, and quicker in thought and act than we are all the time. The marvel of drugs has always been great to my mind; you can madden a man, calm a man, make him incredibly strong and alert or a helpless log, quicken this passion and allay that, all by means of drugs, and here was a new miracle to be added to this strange armoury of phials the doctors use! But Gibberne was far too eager upon his technical points to enter very keenly into my aspect of the question.

It was the 7th or 8th of August when he told me the distillation that would decide his failure or success for a time was going forward as we talked, and it was on the 10th that he

told me the thing was done and the New Accelerator a tangible reality in the world. I met him as I was going up the Sandgate Hill towards Folkestone – I think I was going to get my hair cut; and he came hurrying down to meet me – I suppose he was coming to my house to tell me at once of his success. I remember that his eyes were unusually bright and his face flushed, and I noted even then the swift alacrity of his step.

'It's done,' he cried, and gripped my hand, speaking very fast; 'it's more than done. Come up to my house and see.'

'Really?'

'Really!' he shouted. 'Incredibly! Come up and see.'

'And it does – twice?'

'It does more, much more. It scares me. Come up and see the stuff. Taste it! Try it! It's the most amazing stuff on earth." He gripped my arm and, walking at such a pace that he forced me into a trot, went shouting with me up the hill. A whole charabancful of people turned and stared at us in unison after the manner of people in charabancs. It was one of those hot, clear days that Folkestone sees so much of, every colour incredibly bright and every outline hard. There was a breeze, of course, but not so much breeze as sufficed under these conditions to keep me cool and dry. I panted for mercy.

'I'm not walking fast, am I?' cried Gibberne, and slackened his pace to a quick march.

'You've been taking some of this stuff,' I puffed.

'No,' he said. 'At the utmost a drop of water that stood in a beaker from which I had washed out the last traces of the stuff. I took some last night, you know. But that is ancient history, now.'

'And it goes twice?' I said, nearing his doorway in a grateful perspiration.

'It goes a thousand times, many thousand times!' cried Gibberne, with a dramatic gesture, flinging open his Early English carved oak gate.

'Phew!' said I, and followed him to the door.

'I don't know how many times it goes,' he said, with his latch-key in his hand.

'And you –'

'It throws all sorts of light on nervous physiology, it kicks the theory of vision into a perfectly new shape! ... Heaven knows how many thousand times. We'll try all that after – The thing is to try the stuff now.'

'Try the stuff?' I said, as we went along the passage.

'Rather,' said Gibberne, turning on me in his study. 'There it is in that little green phial there! Unless you happen to be afraid?'

I am a careful man by nature, and only theoretically adventurous. I *was* afraid. But on the other hand there is pride.

'Well,' I haggled. 'You say you've tried it?'

'I've tried it,' he said, 'and I don't look hurt by it, do I? I don't even look livery and I *feel –*'

I sat down. 'Give me the potion,' I said. 'If the worst comes to the worst it will save having my hair cut, and that I think is one of the most hateful duties of a civilised man. How do you take the mixture?'

'With water,' said Gibberne, whacking down a carafe.

He stood up in front of his desk and regarded me in his easy chair; his manner was suddenly affected by a touch of the Harley Street specialist. 'It's rum stuff, you know,' he said.

I made a gesture with my hand.

'I must warn you in the first place as soon as you've got it down to shut your eyes, and open them very cautiously in a minute or so's time. One still sees. The sense of vision is a question of length of vibration, and not of multitude of impacts; but there's a kind of shock to the retina, a nasty giddy confusion just at the time, if the eyes are open. Keep 'em shut.'

'Shut,' I said. 'Good!'

'And the next thing is, keep still. Don't begin to whack about. You may fetch something a nasty rap if you do. Remember you will be going several thousand times faster than you ever did before, heart, lungs, muscles, brain – everything – and you will hit hard without knowing it. You won't know it, you know. You'll feel just as you do now. Only everything in the world will seem to be going ever so many thousand times slower

than it ever went before. That's what makes it so deuced queer.'

'Lor',' I said. 'And you mean –'

'You'll see,' said he, and took up a measure. He glanced at the material on his desk. 'Glasses,' he said, 'water. All here. Mustn't take too much for the first attempt.'

The little phial glucked out its precious contents. 'Don't forget what I told you,' he said, turning the contents of the measure into a glass in the manner of an Italian waiter measuring whisky. 'Sit with the eyes tightly shut and in absolute stillness for two minutes,' he said. 'Then you will hear me speak.'

He added an inch or so of water to the little dose in each glass. 'By-the-by,' he said, 'don't put your glass down. Keep it in your hand and rest your hand on your knee. Yes – so. And now –'

He raised his glass.

'The New Accelerator,' I said.

'The New Accelerator,' he answered, and we touched glasses and drank, and instantly I closed my eyes.

You know that blank non-existence into which one drops when one has taken 'gas.' For an indefinite interval it was like that. Then I heard Gibberne telling me to wake up, and I stirred and opened my eyes. There he stood as he had been standing, glass still in hand. It was empty, that was all the difference.

'Well?' said I.

'Nothing out of the way?'

'Nothing. A slight feeling of exhilaration, perhaps. Nothing more.'

'Sounds?'

'Things are still,' I said. 'By Jove! yes! They *are* still. Except the sort of faint pat, patter, like rain falling on different things. What is it?'

'Analysed sounds,' I think he said, but I am not sure. He glanced at the window. 'Have you ever seen a curtain before a window fixed in that way before?'

I followed his eyes, and there was the end of the

curtain, frozen, as it were, corner high, in the act of flapping briskly in the breeze.

'No,' said I; 'that's odd.'

'And here,' he said, and opened the hand that held the glass. Naturally I winced, expecting the glass to smash. But so far from smashing it did not even seem to stir; it hung in mid-air – motionless. 'Roughly speaking,' said Gibberne, 'an object in these latitudes falls 16 feet in the first second. This glass is falling 16 feet in a second now. Only, you see, it hasn't been falling yet for the hundredth part of a second. That gives you some idea of the pace of my Accelerator.' And he waved his hand round and round, over and under the slowly sinking glass. Finally, he took it by the bottom, pulled it down, and placed it very carefully on the table. 'Eh?' he said to me, and laughed.

'That seems all right,' I said, and began very gingerly to raise myself from my chair. I felt perfectly well, very light and comfortable, and quite confident in my mind. I was going fast all over. My heart, for example, was beating a thousand times a second, but that caused me no discomfort at all. I looked out of the window. An immovable cyclist, head down and with a frozen puff of dust behind his driving-wheel, scorched to overtake a galloping charabanc that did not stir. I gaped in amazement at this incredible spectacle. 'Gibberne,' I cried, 'how long will this confounded stuff last?'

'Heaven knows!' he answered. 'Last time I took it I went to bed and slept it off. I tell you, I was frightened. It must have lasted some minutes, I think – it seemed like hours. But after a bit it slows down rather suddenly, I believe.'

I was proud to observe that I did not feel frightened – I suppose because there were two of us. 'Why shouldn't we go out?' I asked.

'Why not?'

'They'll see us.'

'Not they. Goodness, no! Why, we shall be going a thousand times faster than the quickest conjuring trick that was ever done. Come along! Which way shall we go? Window, or door?'

And out by the window we went.

Assuredly of all the strange experiences that I have ever had, or imagined, or read of other people having or imagining, that little raid I made with Gibberne on the Folkestone Leas, under the influence of the New Accelerator, was the strangest and maddest of all. We went out by his gate into the road, and there we made a minute examination of the statuesque passing traffic. The tops of the wheels and some of the legs of the horses of this charabanc, the end of the whip-lash and the lower jaw of the conductor – who was just beginning to yawn – were perceptibly in motion, but all the rest of the lumbering conveyance seemed still. And quite noiseless except for a faint rattling that came from one man's throat! And as parts of this frozen edifice there were a driver, you know, and a conductor, and eleven people! The effect as we walked about the thing began by being madly queer, and ended by being – disagreeable. There they were, people like ourselves and yet not like ourselves, frozen in careless attitudes, caught in mid-gesture. A girl and a man smiled at one another, a leering smile that threatened to last for evermore; a woman in a floppy capelline rested her arm on the rail and stared at Gibberne's house with the unwinking stare of eternity; a man stroked his moustache like a figure of wax, and another stretched a tiresome stiff hand with extended fingers towards his loosened hat. We stared at them, we laughed at them, we made faces at them, and then a sort of disgust of them came upon us, and we turned away and walked round in front of the cyclist towards the Leas.

'Goodness!' cried Gibberne, suddenly; 'look there!'

He pointed, and there at the tip of his finger and sliding down the air with wings flapping slowly and at the speed of an exceptionally languid snail – was a bee.

And so we came out upon the Leas. There the thing seemed madder than ever. The band was playing in the upper stand, though all the sound it made for us was a low-pitched, wheezy rattle, a sort of prolonged last sigh that passed at times into a sound like the slow, muffled ticking of some monstrous

clock. Frozen people stood erect, strange, silent, self-conscious-looking dummies hung unstably in mid-stride, promenading upon the grass. I passed close to a little poodle dog suspended in the act of leaping, and watched the slow movement of his legs as he sank to earth. 'Lord, look *here*!' cried Gibberne, and we halted for a moment before a magnificent person in white faint-striped flannels, white shoes, and a Panama hat, who turned back to wink at two gaily dressed ladies he had passed. A wink, studied with such leisurely deliberation as we could afford, is an unattractive thing. It loses any quality of alert gaiety, and one remarks that the winking eye does not completely close, that under its drooping lid appears the lower edge of an eyeball and a little line of white. 'Heaven give me memory,' said I, 'and I will never wink again.'

'Or smile,' said Gibberne, with his eye on the lady's answering teeth.

'It's infernally hot, somehow,' said I. 'Let's go slower.'

'Oh, come along!' said Gibberne.

We picked our way among the bath-chairs in the path. Many of the people sitting in the chairs seemed almost natural in their passive poses, but the contorted scarlet of the bandsmen was not a restful thing to see. A purple-faced little gentleman was frozen in the midst of a violent struggle to refold his newspaper against the wind; there were many evidences that all these people in their sluggish way were exposed to a considerable breeze, a breeze that had no existence so far as our sensations went. We came out and walked a little way from the crowd, and turned and regarded it. To see all that multitude changed, to a picture, smitten rigid, as it were, into the semblance of realistic wax, was impossibly wonderful. It was absurd, of course; but it filled me with an irrational, an exultant sense of superior advantage. Consider the wonder of it! All that I had said, and thought, and done since the stuff had begun to work in my veins had happened, so far as those people, so far as the world in general went, in the twinkling of an eye. 'The New Accelerator –' I began, but Gibberne interrupted me.

'There's that infernal old woman!' he said.

'What old woman?'

'Lives next door to me,' said Gibberne. 'Has a lapdog that yaps. Gods! The temptation is strong!'

There is something very boyish and impulsive about Gibberne at times. Before I could expostulate with him he had dashed forward, snatched the unfortunate animal out of visible existence, and was running violently with it towards the cliff of the Leas. It was most extraordinary. The little brute, you know, didn't bark or wriggle or make the slightest sign of vitality. It kept quite stiffly in an attitude of somnolent repose, and Gibberne held it by the neck. It was like running about with a dog of wood. 'Gibberne,' I cried, 'put it down!' Then I said something else. 'If you run like that, Gibberne,' I cried, 'you'll set your clothes on fire. Your linen trousers are going brown as it is!'

He clapped his hand on his thigh and stood hesitating on the verge. 'Gibberne,' I cried, coming up, 'put it down. This heat is too much! It's our running so! Two or three miles a second! Friction of the air!'

'What?' he said, glancing at the dog.

'Friction of the air,' I shouted. 'Friction of the air. Going too fast. Like meteorites and things. Too hot. And, Gibberne! Gibberne! I'm all over pricking and a sort of perspiration. You can see people stirring slightly. I believe the stuff's working off! Put that dog down.'

'Eh?' he said.

'It's working off,' I repeated. 'We're too hot and the stuff's working off! I'm wet through.'

He stared at me. Then at the band, the wheezy rattle of whose performance was certainly going faster. Then with a tremendous sweep of the arm he hurled the dog away from him and it went spinning upward, still inanimate, and hung at last over the grouped parasols of a knot of chattering people. Gibberne was gripping my elbow. 'By Jove!' he cried. 'I believe – it is! A sort of hot pricking and – yes. That man's moving his pocket-handkerchief! Perceptibly. We must get out of this sharp.'

But we could not get out of it sharply enough. Luckily, perhaps! For we might have run, and if we had run we should, I believe, have burst into flames. Almost certainly we should have burst into flames! You know we had neither of us thought of that ... But before we could even begin to run the action of the drug had ceased. It was the business of a minute fraction of a second. The effect of the New Accelerator passed like the drawing of a curtain, vanished in the movement of a hand. I heard Gibberne's voice in infinite alarm. 'Sit down,' he said, and flop, down upon the turf at the edge of the Leas I sat – scorching as I sat. There is a patch of burnt grass there still where I sat down. The whole stagnation seemed to wake up as I did so, the disarticulated vibration of the band rushed together into a blast of music, the promenaders put their feet down and walked their ways, the papers and flags began flapping, smiles passed into words, the winker finished his wink and went on his way complacently, and all the seated people moved and spoke.

The whole world had come alive again, was going as fast as we were, or rather we were going no faster than the rest of the world. It was like slowing down as one comes into a railway station. Everything seemed to spin round for a second or two, I had the most transient feeling of nausea, and that was all. And the little dog which had seemed to hang for a moment when the force of Gibberne's arm was expended fell with a swift acceleration clean through a lady's parasol!

That was the saving of us. Unless it was for one corpulent old gentleman in a bath-chair, who certainly did start at the sight of us and afterwards regarded us at intervals with a darkly suspicious eye, and, finally, I believe, said something to his nurse about us, I doubt if a solitary person remarked our sudden appearance among them. Plop! We must have appeared abruptly. We ceased to smoulder almost at once, though the turf beneath me was uncomfortably hot. The attention of every one – including even the Amusements' Association band, which on this occasion, for the only time in its history, got out of tune – was arrested by the amazing fact, and the still more amazing

yapping and uproar caused by the fact that a respectable, over-fed lap-dog sleeping quietly to the east of the bandstand should suddenly fall through the parasol of a lady on the west – in a slightly singed condition due to the extreme velocity of its movements through the air. In these absurd days, too, when we are all trying to be as psychic, and silly, and superstitious as possible! People got up and trod on other people, chairs were overturned, the Leas policeman ran. How the matter settled itself I do not know – we were much too anxious to disentangle ourselves from the affair and get out of range of the eye of the old gentleman in the bath-chair to make minute inquiries. As soon as we were sufficiently cool and sufficiently recovered from our giddiness and nausea and confusion of mind to do so we stood up and, skirting the crowd, directed our steps back along the road below the Metropole towards Gibberne's house. But amidst the din I heard very distinctly the gentleman who had been sitting beside the lady of the ruptured sunshade using quite unjustifiable threats and language to one of those chair-attendants who have 'Inspector' written on their caps. 'If you didn't throw the dog,' he said, 'who *did*?'

The sudden return of movement and familiar noises, and our natural anxiety about ourselves (our clothes were still dreadfully hot, and the fronts of the thighs of Gibberne's white trousers were scorched a drabbish brown), prevented the minute observations I should have liked to make on all these things. Indeed, I really made no observations of any scientific value on that return. The bee, of course, had gone. I looked for that cyclist, but he was already out of sight as we came into the Upper Sandgate Road or hidden from us by traffic; the charabanc, however, with its people now all alive and stirring, was clattering along at a spanking pace almost abreast of the nearer church.

We noted, however, that the window-sill on which we had stepped in getting out of the house was slightly singed, and that the impressions of our feet on the gravel of the path were unusually deep.

So it was I had my first experience of the New

Accelerator. Practically we had been running about and saying and doing all sorts of things in the space of a second or so of time. We had lived half an hour while the band had played, perhaps, two bars. But the effect it had upon us was that the whole world had stopped for our convenient inspection. Considering all things, and particularly considering our rashness in venturing out of the house, the experience might certainly have been much more disagreeable than it was. It showed, no doubt, that Gibberne has still much to learn before his preparation is a manageable convenience, but its practicability it certainly demonstrated beyond all cavil.

Since that adventure he has been steadily bringing its use under control, and I have several times, and without the slightest bad result, taken measured doses under his direction; though I must confess I have not yet ventured abroad again while under its influence. I may mention, for example, that this story has been written at one sitting and without interruption, except for the nibbling of some chocolate, by its means. I began at 6.25, and my watch is now very nearly at the minute past the half-hour. The convenience of securing a long, uninterrupted spell of work in the midst of a day full of engagements cannot be exaggerated. Gibberne is now working at the quantitative handling of his preparation, with especial reference to its distinctive effects upon different types of constitution. He then hopes to find a Retarder with which to dilute its present rather excessive potency. The Retarder will, of course, have the reverse effect to the Accelerator; used alone it should enable the patient to spread a few seconds over many hours of ordinary time, and so to maintain an apathetic inaction, a glacier-like absence of alacrity, amidst the most animated or irritating surroundings. The two things together must necessarily work an entire revolution in civilised existence. It is the beginning of our escape from that Time Garment of which Carlyle speaks. While this Accelerator will enable us to concentrate ourselves with tremendous impact upon any moment or occasion that demands our utmost sense and vigour, the Retarder will enable us to pass in passive tranquillity through infinite

hardship and tedium. Perhaps I am a little optimistic about the Retarder, which has indeed still to be discovered, but about the Accelerator there is no possible sort of doubt whatever. Its appearance upon the market in a convenient, controllable, and assimilable form is a matter of the next few months. It will be obtainable of all chemists and druggists, in small green bottles, at a high but, considering its extraordinary qualities, by no means excessive price. Gibberne's Nervous Accelerator it will be called, and he hopes to be able to supply it in three strengths: one in 200, one in 900, and one in 2000, distinguished by yellow, pink, and white labels respectively.

No doubt its use renders a great number of very extraordinary things possible; for, of course, the most remarkable and, possibly, even criminal proceedings may be effected with impunity by thus dodging, as it were, into the interstices of time. Like all potent preparations it will be liable to abuse. We have, however, discussed this aspect of the question very thoroughly, and we have decided that this is purely a matter of medical jurisprudence and altogether outside our province. We shall manufacture and sell the Accelerator, and, as for the consequences – we shall see.

Contre les alvéoles

(from 'Mouvements', Face aux
verrous, Paris 1954)

Henri Michaux

Against hive-cells
against glue
the glue one another
the soft one another

Cactus!
Flames of the blackness
impetuous
mothers of daggers
roots of battles shooting out across the plain

Race crawling
Crawl flying
Unity swarming
Solid block dancing

Flung through the window he finally flies
wrenched out from bottom to top
wrenched out of everywhere
wrenched out never to be attached again

Man bracing himself
man on the bounce
man hurtling down
man for operation blitz
for operation storm
for operation assegai
for operation harpoon
for operation shark
for operation wrenching

Man not from flesh
but from emptiness pain internal flames
and gusts and nervous discharges
and reversals
and returns
and rage
and tearing apart
and entanglement
and taking off in sparks

Man not through the abdomen and the gluteal slabs
but through his currents, his weakness bouncing back from shocks
his repeated starts
man according to the moon and burning gunpowder
 and a carnival inside from the movement of others
according to the squall and chaos never mastered
man all flags unfurled, flapping in the wind rustling with his urges
man beating on the topgallant
who has no joints in his body
who does not raise cattle

goat-man
crested man
with spikes,
with shortcuts
tufted man, galvanizing his rags
man with hidden supports, shooting out far from his degrading life

Desire barking in blackness is the multiform form of this being

Surges, scissor-shaped
pitchforked
surges have radiated out
surges all over the Compass Rose

If a body were given
to clamor, to roaring...
To the sounds of the cimbalom, to the piercing drill
to the stamping of adolescents who do not yet know
what their chest wants, as if it were going to burst
To jerks, rumblings, sudden floods
to tides of blood in the heart
to thirst
to thirst above all
to thirst never quenched
if a body were given...

Soul of the lasso
of the seaweed
of the jack, the grapnel and the swelling wave
of the hawk, the walrus and the elephant seal
triple soul
off-center
trouble-maker
soul of an electrified larva coming up to bite at the surface
soul of blows and grinding teeth
soul in shaky balance always about to right itself again

Ignore all heaviness
all languor
all geometry
all architecture
ignore, SPEED!

Movements of tearing apart, of inner exasperation rather than movements of walking
movements of explosion, refusal, of stretching in all directions
of unhealthy attractions, impossible cravings
satisfactions of the flesh banged at the nape of the neck
Headless movements
Who needs a head when one is overwhelmed?
Movements of folding back and coiling around oneself
and of inner shields

movements with many spurts
movements instead of other movements
they cannot be shown, but live in the mind
movements of dust
of stars
of erosion
of landslides
and of vain latencies

Spots in celebration, arms in a scale
movements
you jump into the 'nothing'
revolving efforts
all alone, you are a crowd
What a countless number moving forward
adding, spreading, spreading!
Goodbye fatigue
goodbye cautious biped at the buttress of the bridge
with your sheath ripped away
you are another
any other
You pay tribute no longer
a corolla opens, a bottomless womb
Your stride is as long as hope now
your jump as high as your thought
you have eight legs if you have to run
ten arms if you have to resist
you are rooted deeply when you must hold on

Never beaten
always returning
eternal returner
while the master of the keyboard, soothed, pretends to sleep

Spots
spots to obsess
to reject
to unshelter
to unstabilize
to be reborn
to cross out
to make memory shut its trap
to get going again

Stick gone wild
boomerang returning endlessly
returning torrentially
through others
to take flight once again

Gestures
gestures of the unknown life
of life
of impulsive life
glad to squander
of jerky, spasmodic, erectile life
of life disorderly, life any which way

Gestures of defiance and riposte
and escape from bottlenecks
Gestures of transcendence
of going beyond
above all going beyond
(*pre-gestures* inside oneself, much greater than the visible, practical
 gesture that will follow)

Tanglings
attacks like dives
swims like excavations
arms like elephants' trunks

Joy of driving life
killing the meditation of evil
to what kingdom
does it belong, the bewitching batch that comes out jumping
animal or man
immediate, ceaseless
no sooner gone
than the next one comes in
instantaneous
as from thousands and thousands of seconds
a slow day finds its end

Solitude playing scales
the desert multiplies them
infinitely reiterated arabesques

Signs
not of roof, tunic or palace
not of archives and encyclopedia
but of torsion, violence, jolting
of kinetic desire

Signs of panicked flight, pursuit and fits of rage
of antagonistic, aberrant, dissymmetrical thrusts
signs not critical, but deviating with the deviation and racing with the race
signs not for zoology
but for the face of frantic demons
accompanying our actions and contradicting our restraint

Signs of the million ways of keeping one's balance in this moving world that laughs
 at adaptation
Signs above all to take the self out of the trap of other people's language
designed to win against you, like a well-oiled roulette wheel
allowing you only a few lucky rolls
and ruin and defeat at the end
which were programmed into it beforehand
for you and for everyone else
Signs not to go back
but to 'cross the border' better every second
signs not as we copy
but as we pilot
or, charging blindly ahead, as we are piloted

Signs not to be complete, not to conjugate
but to be faithful to one's 'transient'
Signs to recover the gift of languages
your own at least, for if not you, who will speak it?
At last direct writing to unravel forms
to relieve, to unclutter the images
in public brain-places, particularly clogged at this time

Lacking an aura, at least let us scatter our smells.

Translated by David Ball

Let us first note that the mystics ignore what we have called
'false problems.' It may perhaps be objected that they ignore
all problems, whether real or false, and this is true enough.
It is none the less certain that they supply us with an implicit
answer to questions which force themselves upon the attention
of philosophers, and that difficulties which should never have
perplexed philosophy are implicitly regarded by the mystic as
non-existent. We have shown elsewhere that part of metaphysics
moves, consciously or not, around the question of knowing
why anything exists – why matter, or spirit, or God, rather than
nothing at all? But the question presupposes that reality fills a
void, that underneath Being lies nothingness, that *de jure* there
should be nothing, that we must therefore explain why there is
de facto something. And this presupposition is pure illusion, for
the idea of absolute nothingness has not one jot more meaning
than a square circle. The absence of one thing being always the
presence of another – which we prefer to leave aside because it
is not the thing that interests us or the thing we were expecting
– suppression is never anything more than substitution, a two-
sided operation which we agree to look at from one side only:
so that the idea of the abolition of everything is self-destructive,
inconceivable; it is a pseudo-idea, a mirage conjured up by
our imagination. But, for reasons we have stated elsewhere,
the illusion is natural: its source lies in the depths of the
understanding. It raises questions which are the main origin of
metaphysical anguish. Now, for a mystic these questions simply
do not exist, they are optical illusions arising, in the inner world,
from the structure of human intelligence, they recede and
disappear as the mystic rises superior to the human point of
view. And, for similar reasons, the mystic will no more worry
about the difficulties accumulated by philosophy around the
'metaphysical' attributes of Deity: he has nothing to do with
properties which are mere negations and can only be expressed
negatively; he believes that he sees what God is, for him there
is no seeing what God is not. It is therefore on the nature of
God, immediately apprehended on the positive side, I mean
on the side which is perceptible to the eyes of the soul, that the

philosopher must question him.

The philosopher could soon define this nature, did he wish to find a formula for mysticism. God is love, and the object of love: herein lies the whole contribution of mysticism. About this twofold love the mystic will never have done talking. His description is interminable, because what he wants to describe is ineffable. But what he does state clearly is that divine love is not a thing of God: it is God Himself. It is upon this point that the philosopher must fasten who holds God to be a person, and yet wishes to avoid anything like a gross assimilation with man. He will think, for example, of the enthusiasms which can fire a soul, consume all that is within it, and henceforth fill the whole space. The individual then becomes one with the emotion; and yet he was never so thoroughly himself; he is simplified, unified, intensified. Nor has he ever been so charged with thought, if it be true, as we have said, that there are two kinds of emotion, the one below intellect, which is mere disturbance following upon a representation, the other above intellect, which precedes the idea and is more than idea, but which would burst into ideas if, pure soul that it is, it chose to give itself a body. What is there more systematically architectonic, more reflectively elaborate, than a Beethoven symphony? But all through the labour of arranging, rearranging, selecting, carried out on the intellectual plane, the composer was turning back to a point situated outside that plane, in search of acceptance or refusal, of a lead, an inspiration; at that point there lurked an indivisible emotion which intelligence doubtless helped to unfold into music, but which was in itself something more than music and more than intelligence. Just the opposite of infra-intellectual emotion, it remained dependent on the will. To refer to this emotion the artist had to make a constantly repeated effort, such as the eye makes to rediscover a star which, as soon as it is found, vanishes into the dark sky. An emotion of this kind doubtless resembles, though very remotely, the sublime love which is for the mystic the very essence of God. In any case, the philosopher must bear the emotion in mind when he compresses mystic intuition more and more in order to express it in terms of intelligence.

He may not write music, but he generally writes books; and the analysis of his own state of mind when he writes will help him to understand how the love in which the mystics see the very essence of divinity can be both a person and a creative power. He generally keeps, when writing, within the sphere of concepts and words. Society supplies ideas ready to hand, worked out by his predecessors and stored up in the language, ideas which he combines in a new way, after himself reshaping them to a certain extent so as to make them fit into his combination. This method will always produce some more or less satisfactory result, but still a result, and in a limited space of time. And the work produced may be original and vigorous; in many cases human thought will be enriched by it. Yet this will be but an increase of that year's income; social intelligence will continue to live on the same capital, the same stock. Now there is another method of composition, more ambitious, less certain, which cannot tell when it will succeed or even if it will succeed at all. It consists in working back from the intellectual and social plane to a point in the soul from which there springs an imperative demand for creation. The soul within which this demand dwells may indeed have felt it fully only once in its lifetime, but it is always there, a unique emotion, an impulse, an impetus received from the very depths of things. To obey it completely new words would have to be coined, new ideas would have to be created, but this would no longer be communicating something, it would not be writing. Yet the writer will attempt to realize the unrealizable. He will revert to the simple emotion, to the form which yearns to create its smatter, and will go with it to meet ideas already made, words that already exist, briefly social segments of reality. All along the way he will feel it manifesting itself in signs born of itself, I mean in fragments of its own materialization. How can these elements, each unique of its kind, be made to coincide with words already expressing things? He will be driven to strain the words, to do violence to speech. And, even so, success can never be sure; the writer wonders at every step if it will be granted to him to go on to the end; he thanks his luck for every

partial success, just as a punster might thank the words he comes across for lending themselves to his fun. But if he does succeed, he will have enriched humanity with a thought that can take on a fresh aspect for each generation, with a capital yielding ever-renewed dividends, and not just with a sum down to be spent at once. These are the two methods of literary composition. They may not, indeed, utterly exclude each other, yet they are radically different. The second one, as providing the image of the creation of matter by form, is what the philosopher must have in mind in order to conceive as creative energy the love wherein the mystic sees the very essence of God.

Has this love an object? Let us bear in mind that an emotion of a superior order is self-sufficient. Imagine a piece of music which expresses love. It is not love for any particular person. Another piece of music will express another love. Here we have two distinct emotional atmospheres, two different fragrances, and in both cases the quality of love will depend upon its essence and not upon its object. Nevertheless, it is hard to conceive a love which is, so to speak, at work, and yet applies to nothing. As a matter of fact, the mystics unanimously bear witness that God needs us, just as we need God. Why should He need us unless it be to love us? And it is to this very conclusion that the philosopher who holds to the mystical experience must come. Creation will appear to him as God undertaking to create creators, that He may have, besides Himself, beings worthy of His love.

We should hesitate to admit this if it were merely a question of humdrum dwellers on this corner of the universe called Earth. But, as we have said before, it is probable that life animates all the planets revolving round all the stars. It doubtless takes, by reason of the diversity of conditions in which it exists, the most varied forms, some very remote from what we imagine them to be; but its essence is everywhere the same, a slow accumulation of potential energy to be spent suddenly in free action. We might still hesitate to admit this, if we regarded as accidental the appearance amid the plants and animals that people the earth of a living creature such as

man, capable of loving and making himself loved. But we have shown that this appearance, while not predetermined, was not accidental either. Though there were other lines of evolution running alongside the line which led to man, and though much is incomplete in man himself, we can say, while keeping closely to what experience shows, that it is man who accounts for the presence of life on our planet. Finally, we might well go on hesitating if we believed that the universe is essentially raw matter, and that life has been super-added to matter. We have shown, on the contrary, that matter and life, as we define them, are coexistent and interdependent. This being the case, there is nothing to prevent the philosopher from following to its logical conclusion the idea which mysticism suggests to him of a universe which is the mere visible and tangible aspect of love and of the need of loving, together with all the consequences entailed by this creative emotion: I mean the appearance of living creatures in which this emotion finds in complement; of an infinity of other beings without which they could not have appeared, and lastly of the unfathomable depths of material substance without which life would not have been possible.

No doubt we are here going beyond the conclusions we reached in *Creative Evolution*. We wanted then to keep as close as possible to facts. We stated nothing that could not in time be confirmed by the tests of biology. Pending that confirmation, we had obtained results which the philosophic method, as we understand it, justified us in holding to be true. But we cannot reiterate too often that philosophic certainty admits of degrees, that it calls for intuition as well as for reason, and that if intuition, backed up by science, is to be extended, such extension can be made only by mystical intuition. In fact, the conclusions just set out completely naturally, though not necessarily, those of our former work. Granted the existence of a creative energy which is love, and which desires to produce from itself beings worthy to be loved, it might indeed sow space with worlds whose materiality, as the opposite of divine spirituality, would simply express the distinction between being created and creating, between the multifarious notes,

strung like pearls, of a symphony and the indivisible emotion
from which they sprang. In each of these worlds vital impetus
and raw matter might thus be complementary aspects of
creation, life owing to the matter it traverses its subdivision into
distinct beings, and the potentialities it bears within it being
mingled as much as the spatiality of the matter which displays
them permits. This interpenetration has not been possible
on our planet; everything conduces to the idea that whatever
matter could be secured here for the embodiment of life was
ill-adapted to favour life's impetus. The original impulsion
therefore split into divergent lines of evolutionary progress,
instead of remaining undivided to the end. Even along the line
on which the essential of the impulsion travelled it ended by
exhausting its effect, or rather the movement which started as
straight ended as circular. In that circle humanity, the terminal
point, revolves. Such was our conclusion. In order to carry it
further otherwise than by mere guesswork, we should simply
have to follow the lead of the mystic. That current of life
which traverses matter, and which accounts for its existence,
we simply took for granted. As for humanity, which stands at
the extremity of the main line, we did not ask whether it had
any other purpose but itself. Now, this twofold question is
contained in the very answer given to it by mystical intuition.
Beings have been called into existence who were destined to
love and be loved, since creative energy is to be defined as love.
Distinct from God, Who is this energy itself, they could spring
into being only in a universe, and therefore the universe sprang
into being. In that portion of the universe which is our planet
– probably in our whole planetary system – such beings, in
order to appear, have had to be wrought into a species, which
led up to it, or sustained it, or else formed a residue. It may
be that in other systems there are only individuals radically
differentiated – assuming them to be multifarious and mortal
– and maybe these creatures too were shaped at a single stroke,
so as to be complete from the first. On Earth, in any case, the
species which accounts for the existence of all the others is
only partially itself. It would never for an instant have thought

of becoming completely itself, if certain representatives of itself had not succeeded, by an individual effort added to the general work of life, in breaking through the resistance put up by the instrument, in triumphing over materiality – in a word in getting back to God. These men are the mystics. They have blazed a trail along which other men may pass. They have, by this very act, shown to the philosopher the whence and whither of life.

People are never tired of saying that man is but a minute speck on the fact of the earth, the earth a speck in the universe. Yet, even physically, man is far from merely occupying the tiny space allotted to him, and with which Pascal himself was content when he condemned the "thinking reed" to be, materially, only a reed. For if our body is the matter to which our consciousness applies itself it is coextensive with our consciousness, it comprises all we perceive, it reaches to the stars. But this vast body is changing continually, sometimes radically, at the slightest shifting of one part of itself, which is at its centre and occupies a small fraction of space. This inner and central body, relatively invariable, is ever present. It is not merely present, it is operative: it is through this body, and through it alone, that we can move other parts of the large body. And, since action is what matters, since it is an understood thing that we are present where we act, the habit has grown of limiting consciousness to the small body and ignoring the vast one. The habit appears, moreover, to be justified by science, which holds outward perception to be an epiphenomenon of corresponding intracerebral processes: so that all we perceive of the larger body is regarded as being a mere phantom externalized by the smaller one. We have previously exposed the illusion contained in this metaphysical theory.[1] If the surface of our organized small body (organized precisely with a view to immediate action) is the seat of all our actual movements, our huge inorganic body is the seat of our potential or theoretically possible actions: the perceptive centres of the brain being the pioneers that prepare the way for subsequent actions and plan then from within, everything happens *as though* our external

1
Matière et Mémoire
(Paris, 1896). See the whole
of Chap.I.

perceptions were built up by our brain and launched by it into space. But the truth is quite different, and we are really present in everything we perceive, although through ever varying parts of ourselves which are the abode of no more than potential actions. Let us take matters from this angle and we shall cease to say, even of our body, that it is lost in the immensity of the universe.

It is true that, when people speak of the littleness of man and the immensity of the universe, they are thinking of the complexity of the latter quite as much as of its size. A person appears as something simple; the material world is of a complexity that defies imagination: even the tiniest visible particle of matter is a world in itself. How then can we believe that the latter exists only for the sake of the former? Yet we can and must. For, when we find ourselves confronted with parts which we can go on counting without ever coming to an end, it may be that the whole is simple, and that we are looking at it from the wrong point of view. Move your hand from one point to another: to you who perceive it from the inside this is an indivisible movement. But I who perceive it from the outside, with my attention centred on the line followed, *I* say to myself that your hand has had to cover the first part of the interval, then the half of the second half, then the half of what was left, and so on: I could go on for millions of centuries, and never finish the enumeration of the acts into which, in my eyes, the movement you feel to be indivisible is split up. Thus the gesture which calls into being the human species, or, to use more general terms, the objects of love for the Creator, might well require conditions which require other conditions, and so on, endlessly, to infinity. We cannot think of this multiplicity without bewilderment; yet it is but the reverse of something indivisible. It is true that the infinite numbers into which we decompose a gesture of the hand are purely virtual, necessarily determined in their virtualness by the reality of the gesture, whereas the component parts of the universe, and the parts of these parts, are realities: when they are living beings, they possess a spontaneity which may even attain to free activity. Hence we

are not affirming that the relation between the complex and the simple is the same in both cases. We only wanted to show by the comparison that complexity, even when unlimited, is no proof of importance, and that an existence that is simple may postulate a chain of conditions which never ends.

Such then will be our conclusion. Attributing the place we do to man, and the significance we do to life, it may well appear optimistic. The vision at once rises before us of all the suffering with which life is fraught, from the lowest stage of consciousness up to man. It would be no use for us to contend that among animals this suffering is by no means as great as people think; without going so far as the Cartesian theory of animal-machine, we may presume that pain is much diminished for beings possessing no active memory, who do not protract their past into their resent, and who are not complete personalities; their consciousness is of a somnambulistic nature; neither their pleasure not their pain produce the same deep and enduring reverberations as ours: do we count as real the pain we feel in a dream? Even in man, is not physical distress often due to imprudence or carelessness, or to overrefined tastes, or artificial needs? As for moral distress, it is as often as not our own fault, and in any case it would not be so acute if we had not exasperated our sensibility to the point of making it morbid; our pain is indefinitely protracted and multiplied by brooding over it. In a word, it would be easy to add a few paragraphs to the *Théodicée* of Leibnitz. But we have not the slightest inclination to do so. The philosopher may indulge in speculations of this kind in the solitude of his study; but what is he going to think about it in the presence of a mother who has just watched the passing of her child? No, suffering is a terrible reality, and it is mere unwarrantable optimism to define evil *a priori*, even reduced to what it actually is, as a lesser good. But there is an empirical optimism, which consists simply in noting two facts: first that humanity finds life, on the whole, good, since it clings to it; and then, that there is an unmixed joy, lying beyond pleasure and pain, which is the final state of the mystic soul. In this twofold sense, and from both points

of view, optimism must be admitted, without any necessity for the philosopher to plead the cause of God. It will be said, of course, that if life is good on the whole, yet it would have been better without suffering, and that suffering cannot have been willed by a God of love. But there is nothing to prove that suffering was willed. We have pointed out that what, looked at from one side, appears as an infinite multiplicity of things, of which suffering is indeed one, may look from another side like an indivisible act, so that the elimination of one part would mean doing away with the whole. Now it will be suggested that the whole might have been different, and such that pain had no place in it; therefore that life, even if it is good, could have been better. And the conclusion will be drawn that, if a principle really exists, and if that principle is love, it is not omnipotent and it is therefore not God. But that is just the question. What exactly does 'omnipotence' mean? We have shown that the idea of 'nothing' is tantamount to the idea of a square circle, that it vanished under analysis, leaving only an empty word behind it, in fine that it is a pseudo-idea. May not the same apply to the idea of 'everything,' if this name is given not only to the sum-total of the real, but also to the totality of the possible? I can, at a stretch, represent something in my mind when I hear of the sum-total of existing things, but in the sum-total of the non-existent I can see nothing but a string of words. So that here again the objection is based on a pseudo-idea, a verbal entity. But we can go further still: the objection arises from a whole series of arguments implying a radical defect of method. A certain representation is built up *a priori*, and it is taken for granted that this is the idea of God; from thence are deduced the characteristics that the world ought to show; and if the world does not actually show them, we are told that God does not exist. Now, who can fail to see that, if philosophy is the work of experience and reasoning, it mist follow just the reverse method, question experience as to what it has to teach us of a Being Who transcends tangible reality as He transcends human consciousness, and so appreciate the nature of God by reasoning on the facts supplied by experience?

The nature of God will thus appear in the very reason we have
for believing in His existence: we shall no longer try to deduce
His existence or non-existence from an arbitrary conception
of His nature. Let agreement be reached on this point, and
there will be no objection to talking about divine omnipotence.
We find such expressions used by these very mystics to whom
we turn for experience of the divine. They obviously mean by
this an energy to which no limit can be assigned, and a power
of creating and loving which surpasses all imagination. They
certainly do not evoke a closed concept, still less a definition of
God such as might enable us to conclude what the world is like
or what it should be like.

Translated by R. Ashley Audra and Cloudesley Brereton
With the assistance of W. Horsfall Carter

Shades of Lamarck

The world, unfortunately, rarely matches our hopes and
consistently refuses to behave in a reasonable manner. The
Psalmist did not distinguish himself as an acute observer when
he wrote: "I have been young, and now am old; yet have I not
seen the righteous forsaken, nor his seed begging bread." The
tyranny of what seems reasonable often impedes science. Who
before Einstein would have believed that the mass and aging
of an object could be affected by its velocity near the speed
of light?

Since the living world is a product of evolution, why
not suppose that it arose in the simplest and most direct way?
Why not argue that organisms improve themselves by their
own efforts and pass these advantages to their offspring in the
form of altered genes – a process that has long been called,
in technical parlance, the 'inheritance of acquired characters.'
This idea appeals to common sense not only for its simplicity
but perhaps even more for its happy implication that evolution
travels an inherently progressive path, propelled by the hard
work of organisms themselves. But, as we all must die, and
as we do not inhabit the central body of a restricted universe,
so the inheritance of acquired characters represents another
human hope scorned by nature.

The inheritance of acquired characters usually
goes by the shorter, although historically inaccurate, name
of Lamarckism. Jean Baptiste Lamarck (1744–1829), the
great French biologist and early evolutionist, believed in
the inheritance of acquired characters, but it was not the
centerpiece of his evolutionary theory and was certainly not
original with him. Entire volumes have been written to trace
its pre-Lamarckian pedigree (see Zirkle in bibliography).
Lamarck argued that life is generated, continuously and
spontaneously, in very simple form. It then climbs a ladder
of complexity, motivated by a 'force that tends incessantly
to complicate organization.' This force operates through the
creative response of organisms to 'felt needs.' But life cannot be

organized as a ladder because the upward path is often diverted by requirements of local environments; thus, giraffes acquire long necks and wading birds webbed feet, while moles and cave fishes lose their eyes. Inheritance of acquired characters does play an important role in this scheme, but not the central role. It is the mechanism for assuring that offspring benefit from their parents' efforts, but it does not propel evolution up the ladder.

In the late nineteenth century, many evolutionists sought an alternative to Darwin's theory of natural selection. They reread Lamarck, cast aside the guts of it (continuous generation and complicating forces), and elevated one aspect of the mechanics – inheritance of acquired characters – to a central focus it never had for Lamarck himself. Moreover, many of these self-styled 'neo-Lamarckians' abandoned Lamarck's cardinal idea that evolution is an active, creative response by organisms to their felt needs. They preserved the inheritance of acquired characters but viewed the acquisitions as direct impositions by impressing environments upon passive organisms.

Although I will bow to contemporary usage and define Lamarckism as the notion that organisms evolve by acquiring adaptive characters and passing them on to offspring in the form of altered genetic information, I do wish to record how poorly this name honors a very fine scientist who died 150 years ago. Subtlety and richness are so often degraded in our world. Consider the poor marshmallow – the plant, that is. Its roots once made a fine candy; now its name adheres to that miserable ersatz of sugar, gelatine, and corn syrup.

Lamarckism, in this sense, remained a popular evolutionary theory well into our century. Darwin won the battle for evolution as a fact, but his theory for its mechanism – natural selection – did not win wide popularity until the traditions of natural history and Mendelian genetics were fused during the 1930s. Moreover, Darwin himself did not deny Lamarckism, although he regarded it as subsidiary to natural selection as an evolutionary mechanism. As late as 1938, for example, Harvard palaeontologist Percy Raymond,

writing (I suspect) at the very desk I am now using, said of his colleagues: 'probably most are Lamarckians of some shade; to the uncharitable critic it might seem that many out-Lamarck Lamarck.' We must recognize the continuing influence of Lamarckism in order to understand much social theory of the recent past – ideas that become incomprehensible if forced into the Darwinian framework we often assume for them. When reformers spoke of the 'taint' of poverty, alcoholism, or criminality, they usually thought in quite literal terms – the sins of the father would extend in hard heredity far beyond the third generation. When Lysenko began to advocate Lamarckian cures for the ills of Soviet agriculture during the 1930s, he had not resuscitated a bit of early nineteenth-century nonsense, but a still respectable, if fast fading, theory. Although this tidbit of historical information does not make his hegemony, or the methods he used to retain it, any less appalling, it does render the tale a bit less mysterious. Lysenko's debate with the Russian Mendelians was, at the outset, a legitimate scientific argument. Later, he held on through fraud, deception, manipulation, and murder – that is the tragedy.

Darwin's theory of natural selection is more complex than Lamarckism because it requires *two* separate processes, rather than a single force. Both theories are rooted in the concept of *adaptation* – the idea that organisms respond to changing environments by evolving a form, function, or behaviour better suited to these new circumstances. Thus, in both theories, information from the environment must be transmitted to organisms. In Lamarckism, the transfer is direct. An organism perceives the environmental change, responds in the 'right' way, and passes its appropriate reaction directly to its offspring.

Darwinism, on the other hand, is a two-step process, with different forces responsible for variation and direction. Darwinians speak of genetic variation, the first step, as 'random.' This is an unfortunate term because we do not mean random in the mathematical sense of equally likely in all directions. We simply mean that variation occurs with no

preferred orientation in adaptive directions. If temperatures are dropping and a hairier coat would aid survival, genetic variation for greater hairiness does not begin to arise with increased frequency. Selection, the second step, works upon *unoriented* variation and changes a population by conferring greater reproductive success upon advantageous variants.

This is the essential difference between Lamarckism and Darwinism – for Lamarckism is, fundamentally, a theory of *directed* variation. If hairy coats are better, animals perceive the need, grow them, and pass the potential to offspring. Thus, variation is directed automatically toward adaptation and no second force like natural selection is needed. Many people do not understand the essential role of directed variation in Lamarckism. They often argue: isn't Lamarckism true because environment does influence heredity – chemical and radioactive mutagens increase the mutation rate and enlarge a population's pool of genetic variation. This mechanism increases the *amount* of variation but does not propel it in favoured directions. Lamarckism holds that genetic variation originates *preferentially* in adaptive directions.

In the June 2, 1979, issue of *Lancet*, the leading British medical journal, for example, Dr. Paul E. M. Fine argues for what he calls 'Lamarckism' buy discussing a variety of biochemical paths for the inheritance of acquired, but *nondirected*, genetic variation. Viruses, essentially naked bits of DNA, may insert themselves into the genetic material of a bacterium and be passed along to offspring as part of the bacterial chromosome. An enzyme called 'reverse transcriptase' can mediate the reading of information from cellular RNA 'back' into nuclear DNA. The old idea of a single, irreversible flow of information from nuclear DNA through intermediary RNA to proteins that build the body does not hold in all cases – even though Watson himself had once sanctified it as the 'central dogma' of molecular biology: DNA makes RNA makes protein. Since an inserted virus is an 'acquired character' that can be passed along to offspring, Fine argues that Lamarckism holds in some cases. But Fine has

misunderstood the Lamarckism requirement that characters be acquired for adaptive reasons – for Lamarckism is a theory of directed variation. I have heard no evidence that any of these biochemical mechanisms leads to the preferential incorporation of *favorable* genetic information. Perhaps this is possible; perhaps it even happens. If so, it would be an exciting new development, and truly Lamarckian.

But so far, we have found nothing in the workings of Mendelism or in the biochemistry of DNA to encourage a belief that environments or acquired adaptations can direct sex cells to mutate in specific directions. How could colder weather 'tell' the chromosomes of a sperm or egg to produce mutations for longer hair? How could Pete Rose transfer hustle to his gametes? It would be nice. It would be simple. It would propel evolution at much faster rates than Darwinian processes allow. But it is not nature's way, so far as we know.

Yet Lamarckism holds on, at least in popular imagination, and we must ask why? Arthur Koestler, in particular, has vigorously defended it in several books, including *The Case of the Midwife Toad*, a full-length attempt to vindicate the Australian Lamarckian Paul Kammerer, who shot himself in 1926 (although largely for other reasons) after the discovery that his prize specimen had been doctored by an injection of India ink. Koestler hopes to establish at least a 'mini-Lamarckianism' to prick the orthodoxy of what he views as a heartless and mechanistic Darwinism. I think that Lamarckism retains its appeal for two major reasons.

First, a few phenomena of evolution do appear, superficially, to suggest Lamarckian explanations. Usually, the Lamarckian appeal arises from a misconception of Darwinism. It is often and truly stated, for example, that many genetic adaptations must be preceded by a shift in behaviour without genetic foundation. In a classic and recent case, several species of tits learned to pry the tops off English milk bottles and drink the cream within. One can well imagine a subsequent evolution of bill shape to make the pilferage easier (although it will probably be nipped in the bud by paper cartons and a

cessation of home delivery). Is this not Lamarckian in the sense that an active, nongenetic behavioral innovation sets the stage for reinforcing evolution? Doesn't Darwinism think of the environment as a refining fire and organisms as passive entities before it?

But Darwinism is not a mechanistic theory of environmental determinism. It does not view organisms as billiard balls, buffeted about by a shaping environment. These examples of behavioral imitation are thoroughly Darwinian – yet we praise Lamarck for emphasizing so strongly the active role of organisms as creators of their environment. The tits, in learning to invade milk bottles, established new selective pressures by altering their own environment. Bills of a different shape will now be favoured by natural selection. The new environment does not provoke the tits to manufacture genetic variation directed toward the favored shape. This, and only this, would be Lamarckian.

Another phenomenon, passing under a variety of names, including the 'Baldwin effect' and 'genetic assimilation', seems more Lamarckian in character but fits just as well into a Darwinian perspective. To choose the classic illustration: Ostriches have callosities on their legs where they often kneel on hard ground; but the callosities develop within the egg, before they can be used. Does this not require a Lamarckian scenario: Ancestors with smooth legs began to kneel and acquire callosities as a nongenetic adaptation, just as we, depending on our profession, develop writer's calluses or thickened soles. These callosities were then inherited as genetic adaptations, forming well before their use.

The Darwinian explanation for 'genetic assimilation' can be illustrated with the midwife toad of Paul Kammerer, Koestler's favorite example – for Kammerer, ironically, performed a Darwinian experiment without realizing it. This terrestrial toad descended from aquatic ancestors that grow roughened ridges on their forefeet – the nuptial pads. Males uses these pads to hold the female while mating in their slippery environment. Midwife toads, copulating on *terra firma*, have

lost the pads, although a few anomalous individuals do develop them in rudimentary form – indicating that the genetic capacity for producing pads has not been entirely lost.

Kammerer forced some midwife toads to breed in water and raised the next generation from the few eggs that had survived in this inhospitable environment. After repeating the process for several generations, Kammerer produced males with nuptial pads (even though one later received an injection of India ink, perhaps not by Kammerer, to heighten the effect). Kammerer concluded that he had demonstrated a Lamarckian effect: he had returned the midwife toad to its ancestral environment; it had reacquired an ancestral adaptation and passed it on in genetic form to offspring.

But Kammerer had really performed a Darwinian experiment: when he forced the toads to breed in water, only a few eggs survived. Kammerer had exerted a strong selection pressure for whatever genetic variation encourages success in water. And he reinforced this pressure over several generations. Kammerer's selection had gathered together the genes that favor aquatic life – a combination that no parent of the first generation possessed. Since nuptial pads are an aquatic adaptation, their expression may be tied to the set of genes that confer success in water – a set enhanced in frequency by Kammerer's Darwinian selection. Likewise, the ostrich may first develop callosities as a nongenetic adaptation. But the habit of kneeling, reinforced by these callosities, also sets up new selective pressures for the preservation of random genetic variation that may also code for these features. The callosities themselves are not mysteriously transferred by inheritance of acquired characters from adult to juvenile.

The second, and I suspect more important reason for Lamarckism's continuing appeal, lies in its offer of some comfort against a universe devoid of intrinsic meaning for our lives. It reinforces two of our deepest prejudices – our belief that effort should be rewarded and our hope for an inherently purposeful and progressive world. Its appeal for Koestler and other humanists lies more with this solace than in any technical

argument about heredity. Darwinism offers no such consolation for it holds only that organisms adapt to local environments by struggling to increase their own reproductive success. Darwinism compels us to seek meaning elsewhere – and isn't this what art, music, literature, ethical theory, personal struggle, and Koestlerian humanism are all about? Why make demands of nature and try to restrict her ways when the answers (even if they are personal and not absolute) lie within ourselves?

Thus Lamarckism, so far as we can judge, is false in the domain it has always occupied – as a biological theory of genetic inheritance. Yet, by analogy only, it is the mode of 'inheritance' for another and very different kind of 'evolution' – human cultural evolution. *Homo sapiens* arose at least 50,000 years ago, and we have not a shred of evidence for any genetic improvement since then. I suspect that the average Cro-Magnon, properly trained, could have handled computers with the best of us (for what it's worth, they had slightly larger brains than we do). All that we have accomplished, for better or for worse, is a result of cultural evolution. And we have done it at rates unmatched by orders of magnitude in all the previous history of life. Geologists cannot measure a few hundred or a few thousand years in the context of our planet's history. Yet, in this millimicrosecond, we have transformed the surface of our planet through the influence of one unaltered biological invention – self-consciousness. From perhaps one hundred thousand people with axes to more than four billion with bombs, rocket ships, cities, televisions, and computers – and all without substantial genetic change.

Cultural evolution has progressed at rates that Darwinian processes cannot begin to approach. Darwinian evolution continues in *Homo sapiens*, but at rates so slow that it no longer has much impact on our history. This crux in the earth's history has been reached because Lamarckian processes have finally been unleashed upon it. Human cultural evolution, in strong opposition to our biological history, is Lamarckian in character. What we learn in one generation, we transmit directly by teaching and writing. Acquired characters are inherited in

technology and culture. Lamarckian evolution is rapid and
accumulative. It explains the cardinal difference between
our past, purely biological mode of change, and our current,
maddening acceleration toward something new and liberating
– or toward the abyss.

René Daumal

The simple fact of the matter is beyond telling. In the eighteen
years since it happened, I have often tried to put it into words.
Now, once and for all, I should like to employ every resource
of language I know in giving an account of at least the outward
and inward circumstances. This 'fact' consists in a certainty I
acquired by accident at the age of sixteen or seventeen; ever
since then, the memory of it has directed the best part of me
toward seeking a means of finding it again, and for good.

 My memories of childhood and adolescence are deeply
marked by a series of attempts to experience the beyond, and
those random attempts brought me to the ultimate experiment,
the fundamental experience of which I speak. At about the age
of six, having been taught no kind of religious belief whatsoever,
I struck up against the stark problem of death. I passed some
atrocious nights, feeling my stomach clawed to shreds and
my breathing half throttled by the anguish of nothingness, the
'no more of anything.' One night when I was about eleven,
relaxing my entire body, I calmed the terror and revulsion of
my organism before the unknown, and a new feeling came alive
in me; hope, and a foretaste of the imperishable. But I wanted
more, I wanted a certainty. At fifteen or sixteen I began my
experiments, a search without direction or system.

 Finding no way to experiment directly on death – on
my death – I tried to study my sleep, assuming an analogy
between the two. By various devices I attempted to enter sleep
in a waking state. The undertaking is not so utterly absurd as it
sounds, but in certain respects it is perilous. I could not go very
far with it; my own organism gave me some serious warnings of
the risks I was running. One day, however, I decided to tackle
the problem of death itself. I would put my body into a state
approaching as close as possible that of physiological death,
and still concentrate all my attention on remaining conscious
and registering everything that might take place. I had in my
possession some carbon tetrachloride, which I used to kill
beetles for my collection. Knowing this substance belongs to
the same chemical family as chloroform (it is even more toxic),
I thought I could regulate its action very simply and easily: the

moment I began to lose consciousness, my hand would fall
from my nostrils carrying with it the handkerchief moisturised
with the volatile fluid. Later on I repeated the experiment in
the presence of friends, who could have given me help had
I needed it. The result was always exactly the same; that is, it
exceeded and even overwhelmed my expectations by bursting
the limits of the possible and by projecting me brutally into
another world.

First came the ordinary phenomena of asphyxiation:
arterial palpitation, buzzings, sounds of heavy pumping in the
temples, painful repercussions from the tiniest exterior noises,
flickering lights. Then, the distinct feeling: 'This is getting
serious. The game is up,' followed by a swift recapitulation
of my life up to that moment. If I felt any slight anxiety, it
remained indistinguishable from a bodily discomfort that did
not affect my mind. And my mind kept repeating to itself:
'Careful, don't doze off. This is just the time to keep your eyes
open.' The luminous spots that danced in front of my eyes
soon filled the whole of space, which echoed with the beat of
my blood – sound and light overflowing space and fusing in a
single rhythm. By this time I was no longer capable of speech,
even of interior speech; my mind travelled too rapidly to carry
any words along with it. I realized, in a sudden illumination, that
I still had control of the hand which held the handkerchief, that
I still accurately perceived the position of my body, and that
I could hear and understand words uttered nearby – but that
objects, words, and meanings of words had lost any significance
whatsoever. It was a little like having repeated a word over and
over until it shrivels and dies in your mouth: you still know
what the word 'table' means, for instance, you could use it
correctly, but it no longer truly evokes its object. In the same
way everything that made up 'the world' for me in my ordinary
state was still there, but I felt as if it had been drained of its
substance. It was nothing more than a phantasmagoria – empty,
absurd, clearly outlined, and necessary all at once. This 'world'
lost all reality because I had abruptly entered another world,
infinitely more real, an instantaneous and intense world of

eternity, a concentrated flame of reality and evidence into which
I had cast myself like a butterfly drawn to a lighted candle.
Then, at that moment, comes the *certainty*; speech must now
be content to wheel in circles around the bare fact.

Certainty of what? Words are heavy and slow, words are
too shapeless or too rigid. With these wretched words I can put
together only approximate statements, whereas *my certainty* is
for me the archetype of precision. In my ordinary state of mind,
all that remains thinkable and formulable of this experiment
reduces to one affirmation on which I would stake my life: I
feel the certainty of the existence of *something else*, a beyond,
another world, or another form of knowledge. In the moment
just described, I knew directly, I experienced that beyond in
its very reality. It is important to repeat that in that new state
I perceived and perfectly comprehended the ordinary state of
being, the latter being contained within the former, as waking
consciousness contains our unconscious dreams, and not the
reverse. This last irreversible relation proves the superiority (in
the scale of reality or consciousness) of the first state over the
second. I told myself clearly: in a little while I shall return to
the so-called 'normal state,' and perhaps the memory of this
fearful revelation will cloud over; but it in this moment that I
see the truth. All this came to me without words; meanwhile
I was pierced by an even more commanding thought. With a
swiftness approaching the instantaneous, it thought itself so
to speak in my very substance: for all eternity I was trapped,
hurled faster and faster towards ever imminent annihilation
through the terrible mechanism of the Law that rejected me.
'That's what it is. So that's what it is.' My mind found no other
reaction. Under the threat of something *worse*, I had to follow
the movement. It took a tremendous effort, which became
more and more difficult, but I was *obliged* to make that effort,
until the moment when, letting go, I doubtless fell into a brief
spell of unconsciousness. My hand dropped the handkerchief,
I breathed air, and for the rest of the day I remained dazed and
stupefied – with a violent headache.

I shall now try to bring that wordless *certainty* into

focus by means of images and concepts. To begin with, it must be understood that this certainty exists on a *higher level of significance* than that of our usual thoughts. We are accustomed to use images or illustrations to signify concepts; for example a drawing of a circle to represent the concept of a circle. In the state I am describing the concept itself is no longer the final term, the thing signified; the concept – or idea in the usual sense of the word – is itself the sign of something higher. Let me recall that at the moment when the *certainty* revealed itself, my ordinary intellectual mechanisms continued to function; images took shape, ideas and judgments formed in my mind, but free from the weight and tangle of words. This last condition accelerated these operations to the speed of simultaneousness that they often have in moments of great danger – as when one falls while mountain climbing for example.

Thus the images and concepts I am going to describe were present at the time of the experiment on a level of reality intermediate between the appearance of our everyday 'exterior world' and the *certainty* itself. A few of these images and concepts, however, grew out of my having written down later a partially coherent account. Such an account was necessary, for as soon as I wanted to relate the experience to anyone, and first of all to myself, I had to use words and therefore to develop certain implicit aspects of these images and concepts.

Even though the two occurred simultaneously, I shall start with the images. They were both visual and auditory. In the first case, they took the form of what seemed a veil or screen of luminous spots, a veil more real than the ordinary 'world,' which I could still make out behind it. A circle, half red and half black, inscribed itself in a triangle coloured in the same fashion, with the red half-circle against the black segment of triangle, and vice versa. And all space was endlessly divided thus into circles and triangles inscribed within one another, combing and moving in harmony, and changing into one another in a geometrically inconceivable manner that could not be reproduced in ordinary reality. A sound accompanied this luminous movement, and I suddenly realized it was I who

was making it. In fact I virtually *was* that sound; I sustained
my existence by emitting it. The sound consisted of a chant
or formula, which I had to repeat faster and faster in order to
'follow the movement.' That formula (I give the facts with no
attempt to disguise their absurdity) ran something like this:
'Tem gwef tem gwef dr rr rr,' with an accent on the second
'gwef' and with the last syllable blending back into the first; it
gave an unceasing pulse to the rhythm, which was, as I have
said, that of my very being. I knew that as soon as it began
going too fast for me to follow, the unnameable and frightful
thing would occur. In fact it was always *infinitely close* to
happening, and infinitely remote... that is all I can say.

 The concepts revolve around a central idea of *identity*:
everything is perpetually one and the same. They took the form
of spatial, temporal, and numerical diagrams – diagrams that
were present at the time but whose separation into these
categories naturally came later along with the verbal description.

 The space in which these shapes arose was not
Euclidean, for it was so constructed that an indefinite
extension of a point returned to itself. That is, I believe,
what mathematicians call 'curved space.' Transposed into
a Euclidian scheme, the movement could be described as
follows. Imagine an immense circle whose circumference
reaches the infinite and which is perfect and unbroken *except
for one point*; subsequently this point expands into a circle that
grows indefinitely, extends its circumference to infinity and
merges with the original circle, perfect, pure and unbroken
except for one point, which expands into a circle... and so on
unceasingly, and in fact instantaneously, for at each instant the
circumference, enlarged to infinity, reappears simultaneously
as a *point*; not a central point, that would be too perfect, but an
eccentric point that represents at the same time the nothingness
of my existence and the disequilibrium that my existence,
by its particularity, introduces into the immense circle of the
All – the All which perpetually *obliterates me*, reasserting its
undiminished integrity. For it is I alone who am *diminished*.

 In respect to time, the scheme of things is perfectly

analogous. This movement of an indefinite expansion returning to its origin takes place as duration (a 'curved' duration) as well as space: the last movement is forever identical with the first, it all vibrates simultaneously in an instant, and only the necessity of representing all this in our ordinary 'time' obliges me to speak of an infinite *repetition*. What I see I have always seen and shall always see, again and again; everything recommences in identical fashion at each instant, as if the total nullity of my particular existence within the unbroken substance of the Immobile were the cause of a cancerous proliferation of instants.

In respect to *number*, the indefinite multiplication of points, circles, and triangles dissolves the same way, instantaneously, into a regenerated Unity, perfect *except for me*; and this *except for me*, throwing the unity of the All into disequilibrium, engenders an indefinite and instantaneous Unity, perfect *except for me*... and everything starts all over again, always in the same place, in the same eternal instant, and without producing any true alteration in the nation of the All.

If I continued thus to try to enclose my *certainty* in any sequence of logical categories, I should be reduced to the same absurd expressions: in the category of causality, for example, cause and effect perpetually blending into one another and separating from one another, passing from one pole to the other because of the disequilibrium produced in their substantial identity by the infinitesimal hole which I am.

I have said enough to make it clear that the certainty of which I speak is in equal degrees mathematical, experimental, and emotional: a *mathematical* certainty – or rather *mathematico-logical* – as one can understand indirectly in the conceptual description I have just attempted and which can be abstractly stated as follows: the identity of the existence and the non-existence of the finite in the infinite; an *experimental* certainty, not only because it is based on direct vision (that would be observation and not necessarily experimentation), not only because the experiment can be repeated at any time, but because I ceaselessly tested the certainty in my struggle

to 'follow the movement' that rejected me, a struggle in
which I could only repeat the little chant I had found as my
sole response; an *emotional* certainty because in the whole
affair – the core of the experiment lies here – it is I who am
at stake: I saw my own nothingness face to face, or rather my
perpetual annihilation, total but not absolute annihilation:
a mathematician will understand me when I describe it as
'asymptote.'

 I insist on the triple nature of this certainty in order
to anticipate three kinds of incomprehension in the reader.
First, I want to keep lazy minds from falling into the illusion
of understanding me when they find only a vague sense of
the mystery of the beyond to correspond to my mathematical
certainty. Second, I want to prevent psychologists and
especially psychiatrists from treating my testimony not as
testimony at all but as an interested psychic manifestation
worth study and explaining by what they believe to be their
'psychological science.' It is in order to forestall their attempts
that I have insisted on the experimental nature (and not
simply the introspective experience) of my certainty. Third,
at the very heart of this certainty, the cry: 'It's I, I who am at
stake,' should frighten the curious who think they might like to
perform the same or a similar experiment. I warn them now,
it is a terrifying experience, and if they want more precise
information on its dangers, they can ask me in private. I do
not mean the physiological dangers (which are very great),
for if, in return for accepting grave illness or infirmity, or for a
considerable shortening of the span of physical life, one could
attain to a *single* certainty, the price would not be too high. I
am not speaking, moreover, only of the dangers of insanity or
of damage to the mind, which I escaped by extraordinary good
luck. The danger is far graver, comparable to what happened
to Bluebeard's wife: she opens the door of the forbidden room,
and the horrible spectacle sears her innermost being as with
a white-hot iron. After the first experiment, in effect, I was
'unhinged' for several days, cut adrift from what is customarily
called 'the real.' Everything seemed to me an absurd

phantasmagoria, no logic could convince me of anything, and, like a leaf in the wind, I was ready to obey the faintest interior or exterior impulse. This state almost involved me in irreparable 'actions' (if the word still applies), for nothing held any importance for me any longer. I subsequently repeated the experiment several times, always with exactly the same result; or rather I always found the same moment, the same instant eternally coexisting with the illusory unfolding of my life. Having once seen the danger, however, I stopped repeating the test. Nevertheless, several years later I was given an anaesthetic for a minor operation. The identical thing happened: I confronted the same unique instant, this time, it is true, to the point of total unconsciousness.

My certainty, naturally, had no need of exterior confirmation; rather it suddenly cleared up for me the meaning of all kinds of narratives that other men have tried to make of the same revelation. I understood, in effect, that I was not the only one, not an isolated or pathological case in the cosmos. First of all, several of my friends tried the same experiment. For the most part nothing happened except the ordinary phenomena preceding narcosis. Two of them went a little further, but brought back with them only vague recollections of a profound bewilderment. One said it was like the advertisements for a certain aperitif, in which two waiters are carrying two bottles, whose labels show two waiters carrying two bottles, whose labels... The other painfully searched his memory in the attempt to explain: 'Ixian, ixian i, ixian, ixian i...' It was obviously his version of 'Tem gwef tem gwef dr rr rr...' But a third friend experienced exactly the same reality that I had encountered, and we needed only to exchange a look to know we had seen the same thing. It was Roger Gilbert-Lecomte, with whom I was to edit the review, *Le Grand Jeu*; its tone of profound conviction was nothing more than the reflection of the certainty we shared. And I am convinced that this experience determined the direction his life would take as it did mine, even if somewhat differently.

Little by little I discovered in my reading accounts of

the same experience, for I now held the key to these narratives and descriptions whose relation to a single and unique reality I should not previously have suspected. William James speaks of it. O.V. de L. Milosz, in his *Letter to Storge*, gives an overwhelming account of it in terms I had been using myself. The famous circle referred to by a medieval monk, and which Pascal saw (but who first saw it and spoke of it?) ceased to be an empty allegory for me; I knew it represented a devouring vision of what I had seen also. And, beyond all this varied and partial human testimony (there is scarcely a single true poet in whose work I did not find at least a fragment of it), the confessions of the great mystics and, still more advanced, the sacred texts of certain religions, brought me an affirmation of the same reality. Sometimes I found it in its most terrifying form, as perceived by an individual of limited vision who has not raised himself to the level of such perception, who, like myself, has tried to look into the infinite through the keyhole and finds himself staring into Bluebeard's cupboard. Sometimes I encountered it in the pleasing, plentifully satisfying and immensely luminous form that is the vision of beings truly transformed, who can behold that reality face to face without being destroyed by it. I have in mind the revelation of the Divine Being in the *Bhagavad-Gita*, the vision of Ezekiel and that of St. John the Divine on Patmos, certain descriptions in the *Tibetan Book of the Dead (Bardo thôdol)*, and a passage in the *Lankàvâtra-Sûtra*.

Not having lost my mind then and there, I began little by little to philosophize about the memory of this experience. And I would have buried myself in a philosophy of my own if someone had not come along just in time to tell me: 'Look, the door is open – narrow and hard to reach, but a door. It is the only one for you.'

Translated by Roger Shattuck

Interview with Paolo Fabbri about
Valerio and Other Urban Rumours
Café de Flore, Paris 1999
From an interview by
Hans Ulrich Obrist with questions by
Dominique Gonzalez-Foerster and
Philippe Parreno

Hans Ulrich Obrist: Can we talk about the urban rumour
Valerio?

Paolo Fabri: It's not pronounced as a proper name – You say
'Paolo' or 'Jim', you don't say 'Paaooloo!' or 'Jiiiim!'. It's a
cry, and a special cry, [shouts] 'Valeriooo!', and this is very
important.

HUO We didn't know this you see because we only read about
it. I only experienced it once in Italy, and this was in a motel.
I wasn't sure if it was real or if it was a dream [laughs]. So you
don't pronounce it 'Valerio'?

PF It's 'Valeriooooo!'

HUO Tell me again the story about those people who want to
be Valerio; many people identify with Valerio.

PF For example, in the newspapers I found at least three or
four people who assume and purport to be Valerio. They think
this is not just a cry, but that it has the capacity for designation
a proper name that is a cry with a specific prosodic feature.
I hear a lot of explanations for the Valerio phenomenon. Theory
number one: A man with a TV camera, perched in a very high
place during the World Motor championships, in Italy near
Immola. There were 3,000 people waiting in the sun, bored.
So high up there is this man trying to do the camera work who
would say 'Valerioooo!'. The crowd, waiting for the cars with
nothing to do, began to repeat the cry. Second story: During a
rock concert in Bascarosa...

HUO I heard it was Brindisi?

PF There are a lot of places pretending to be 'the' place, one
is Bascarosa. The common denominator in all the stories is a
crowd of people bored and waiting attentively for the beginning
of something. Someone cries 'Valeriooo', and someone

responds 'Valeriooo!' I'll try to make a generalisation: when you have a lot of people together with nothing to do, just waiting around, they have to do something. It's very appropriate for communication to say or cry something. The other explanation is more complex, a perfect metaphor for political public communication today when you cry in a very high voice that you have nothing to say. If you have content (e.g. 'death to fascists'), another person may refuse your content, but if you have no content, no one has a reason to refuse to say it.

HUO When and how did Valerio first come to your attention?

PF The first time was... people were going very fast, in bicycles, in cars, very fast, but this is because my brother is the owner of a large discotheque in Rimini and he is my indigenous informer. He said 'Paolo, there is a new wave: people are crying Valerio in my discotheque. While dancing, someone begins to cry "Valerioooo!" and everyone follows.'

HUO In the viral dimension, it went to Torino and some other cities in Italy, but it didn't go to Palermo or Naples.

PF It was very fashionable to cry Valerio into your portable phone.

HUO We thought it was very interesting to shout Valerio in London, in France, then in Berlin... The place where people like it the least is London, because in London people think it's Brazilian football hooliganism. This is really interesting ... Why do you think it started in Italy? Whenever I'm in Italy I observe this obsession with cellular phones, and then the obsession with Valerio.

PF Because in many ways Italy is a conformist country. In fact Italians are very ironic; it's both. They don't say Valerio because they believe in it; it's precisely because they don't believe in it. Its circulation is permitted because there is no belief involved.

If it had belief, value, or meaning in the narrow sense, they
would never repeat it. They repeat it because it's ironic, a
quotation of other people, 'it's not my Valerio, I'm just repeating
it'. It's not 'your cry, it's a cry in commas, repeating the cry of
the other. Italians are fashion conscious, and fashion entails
a somewhat conformist attitude, but at the same time they
practice a very ironic form of conformism.

HUO In different chapters, you show that Valerio doesn't have
an origin that can be pinned down, it's very ambiguous. But
in the reception by the press outside of Italy, in Germany, in
France and in England, there always appeared this story of the
sound technician, Valerio, who had disappeared.

PF The definition of 'rumour' is that there is no possibility to
find its source. The source is constantly retreating and fading.
From this point of view, the fading of Valerio will necessitate
the attempt to find its source. Infinite regression of course.
I'm sure we will never discover it, as is generally the case with
urban legends.

Self-awareness in Animals and Humans
Developmental Perspectives
Edited by Sue Taylor Parker,
Robert W Mitchell, Maria L Bocca

Mutual Awareness in Primate Communication:
A Gricean Approach
Juan Carlos Gómez

The mechanism of human communication seems to involve some explicit representation of the process of information transmission. When I as someone to allow me to pass through the door, I seem to be aware of the informational nature of the effect I am trying to provoke. Let us examine what this implies by analyzing a simple act of communication (Figure 5.1). When I say to the waiter in the example 'May I have some salt, please,' I don't want the waiter just to give me the salt. My representation of the situation is not merely, 'If I say, "May I have some salt, please," he will give me the salt.' I not only understand that my words will provoke a reaction in the waiter, I also understand something about why this will happen. I understand that the waiter will give me the salt because *he will understand* that I want it. When I speak the above sentence, I want the waiter to understand that I want the salt, that is, I am taking into account the mental process in the waiter that will allow him to answer my request. Note that, as shown in Figure 5.1, this implies a remarkable mental structure in which the waiter is represented as achieving a representation of the client's desire (which is, in turn, a representation of something; in this case, the salt). It is frequently assumed that this remarkable series of three embedded representations is the essence of the Gricean account of communication (e.g., Cheney & Seyfarth, 1990 [1] ; Dennett, 1983 [2]), and it has even been termed the *Gricean mechanism* (Bennett, 1976 [3]). Nevertheless, according to my own interpretation, the Gricean account involves more than that.

Consider the following situation: I have had a quarrel with the waiter of Figure 5.1, and I promise myself never to talk again to such a nasty man. Then I discover that my salt cellar is empty. To get the salt without breaking my promise, I act as follows: I covertly watch the waiter until I see that he is looking in the direction of my table. Then I take the empty salt cellar

1
Cheney & Seyfarth
Cheney, D.L., & Seyfarth, R.M. (1990). *How monkeys see the world*. Chicago: University of Chicago Press.
2
Bennett, J. (1976). *Linguistic behavior*. Cambridge University Press.
3
Dennett, D.C. (1983). Intentional systems in cognitive ethology: The panglossian paradigm defended. *Behavioral and Brain Sciences, 6*, 343–390.

Figure 5.1. A moderate Gricean interpretation of a simple request for salt. The speaker is assumed to have a third-order intentional representation encompassing his own and his listener's mental states: *A* wants *B* to *understand* that he *wants* some salt. (See text.)

Figure 5.2. A truly Gricean interpretation of a requestive situation. The speaker entertains a fifth-order level of intentionality: *A* wants *B* to *understand* that he *wants* him to *understand* that he *wants* the salt. (See the text for further explanations.)

and try to get salt out of it acting as if I were discovering its
emptiness then. I hope that the waiter, upon seeing my trouble,
will bring me some salt. If I succeed, the waiter will bring the
salt without my having requested it. Note, however, that if my
scheme works, I will have made the waiter to understand that I
want the salt. The plan I entertain in my mind can be described
as follows: I want the waiter to understand that I want the salt,
and this coincides with the alleged Gricean mechanism of
Figure 5.1. Now, if an act that is not a request has this structure,
a true request must present a different one.

 Perhaps someone would want to argue that, though
covert, the above action is a request. Nevertheless, everybody
would agree that there is an important difference between this
action and the overt request in which I turn to the waiter, show
him the empty salt cellar, and ask him, 'May I have some salt,
please?' What is this essential difference? In the covert version,
although it is true that I want the waiter to understand that I
want the salt, I don't want him to be aware of my purpose, that
is, I want him to understand that I want the salt, but I don't
want him to understand that I want him to understand that I
want the salt. This – the missing element in the above example
– is the essence of human communication from a Gricean point
of view. In a genuine communicative act, I want the listener to
understand that I *intend* him to understand what I want from
him (Figure 5.2). Thus, in our example, a true communicative
act would involve that I want the waiter to understand that
I want him to understand that I want the salt: a series of *five*
embedded mental states. This spiral of mutual understandings
can be appropriately called a *Gricean loop*, in reference to their
circular and entangled nature (see Grice, 1957)[4].

 Note that the loop also exists on the receiver's side:
In an overt request the waiter will give me the salt because he
understand that I want him to understand that I want him to
understands that I want the salt. This contrasts with the covert
maneuver which, if successful, will lead the waiter to give me
the salt only because he becomes aware that I want the salt.
The reader can have an idea of the complexity such loops can

4
Grice, H.P. (1957)
Meaning. *Philosophical
Review*, 66, 377–388.

reach if he considers the case in which the waiter notices the true intention behind my covert maneuver. If the waiter notices my covert watching before enacting my false discovery of the empty salt cellar, he will probably understand something like the following: that I want him to believe that I want some salt, but I don't want him to understand that I want him to know what I want – a remarkably entangled instance of a Gricean loop.

Thus, my interpretation of the Gricean account of communication is that it requires a minimum of five embedded mental states on the part of the speaker, and six on the part of the listener.

Ilinx. The last kind of game includes those which are based
on the pursuit of vertigo and which consist of an attempt to
momentarily destroy the stability of perception and inflict a
kind of voluptuous panic upon an otherwise lucid mind. In all
cases, it is a question of surrendering to a kind of spasm, seizure
or shock which destroys reality with sovereign brusqueness.

The disturbance that provokes vertigo is commonly
sought for its own sake, I need only cite as examples the actions
of whirling dervishes and the Mexican *valodores.* I choose
these purposely, for the former, in technique employed, can
be related to certain children's games, while the latter rather
recall the elaborate maneuvers of high-wire acrobatics. They
thus touch the two poles of games of vertigo. Dervishes seek
ecstasy by whirling about with movements accelerating as the
drumbeats become ever more precipitate. Panic and hypnosis
are attained by the paroxysm of frenetic, contagious, and
shared rotation. In Mexico, the *valodores* – Haustec or Totonac
– climb to the top of a mast sixty-five to one hundred feet high.
They are disguised as eagles with false wings hanging from
their wrists. The rope then passes between their toes in such a
way that they can manage their entire descent with head down
and arms outstretched. Before reaching the ground, they make
complete turns, thirty according to Torquemada, describing an
ever-widening spiral in their downward flight. The ceremony,
comprising several flights and beginning at noon, is readily
interpreted as a dance of the setting sun, associated with
birds, the deified dead. The frequency of accidents has led the
Mexican authorities to ban this dangerous exercise. [1]

It is scarcely necessary to invoke these rare and
fascinating examples. Every child very well knows that by
whirling rapidly he reaches a centrifugal state of flight from
which he regains bodily stability and clarity of perception only
with difficulty. The child engages in this activity playfully and
finds pleasure thereby. An example is the game of teetotum [2]
in which the player pivots on one foot as quickly as he is able.
Analogously, in the Haitian game of *maïs d'or* two children
hold hands, face to face, their arms extended. With their bodies

[1]
Description and
photographs in Helga
Larsen, 'Notes on
the Volador and Its
Associated Ceremonies
and Superstitions',
Ethnos, 2, No.4 (July,
1937), 179–192, and
in Guy Stresser-Péan,
'les origins du volador
et du comelagatoazte,'
*Actes du XXVIIIe
Congres International
des Amèricanistes* (Paris,
1947), 327–334. I quote
part of the description of
the ceremony from this
article [translated by M.B.
from French text]:
'The chief of the
dance or K'ohal, clad in a
red and blue tunic, ascends
in his turn and sits on the
terminal platform. Facing
east, he first invokes the
benevolent deities, while
extending his wings in
their direction and using a
whistle which imitates the
puling of eagles. Then he
climbs on top of the mast.
Facing the four points of
the compass in succession,
he offers them a chalice of
calabash wrapped in the
white linen just like a bottle
of brandy, from which he
sips and spits some more or
less vaporized mouthfuls.
Once this symbolic offering
has been made, he puts on
his headdress of red feathers
and dances, facing all four
directions while beating
his wings.

stiffened and bent backward, and with their feet joined, they turn until they are breathless, so that they will have the pleasure of staggering about after they stop. Comparable sensations are provided by screaming as loud as one can, racing downhill, and tobogganing; in horsemanship, provided that one turns quickly; and in swinging.

Various physical activities also provoke these sensations, such as the tightrope, falling or being projected into space, rapid rotation, sliding, speeding, and acceleration of vertilinear movement, separately or in combination with gyrating movement. In parallel fashion, there is a vertigo of a moral order, a transport that suddenly seizes the individual. This vertigo is readily linked to the desire for disorder and destruction, a drive which is normally repressed. It is reflected in crude and brutal forms of personality expression. In children, it is especially observed in the games of hot cockles, 'winner-take-all,' and leapfrog in which they rush and spin pell-mell. In adults, nothing is more revealing of vertigo than the strange excitement that is felt in cutting down the tall prairie flowers with a switch, or in creating an avalanche of the snow on a rooftop, or, better, the intoxication that is experienced in military barracks – for example, in noisily banging garbage cans.

To cover the many varieties of such transport, for a disorder that may take organic or psychological form, I propose using the term *ilinx*, the Greek term for whirlpool, from which is also derived the Greek word for vertigo (*ilingos*).

This pleasure is not unique to man. To begin with, it is appropriate to recall the gyrations of certain animals, sheep in particular. Even if these are pathological manifestations, they are too significant to be passed over in silence. In addition, examples in which the play element is certain are not lacking. In order to catch their tails dogs will spin around until they fall down. At other times they are seized by a fever for running until they are exhausted. Antelopes, gazelles, and wild horses are often panic-stricken when there is no real danger in the slightest degree to account for it; the impression is of an overbearing

1 *(cont.)*
'These ceremonies executed at the summit of the mast mark what the Indians consider the most moving phase of the ritual, because it involves mortal risk. But the next stage of the 'flight' is even more spectacular. The four dancers, attached by the waist, pass underneath the structure, then let themselves go from behind. Thus suspended, they slowly descend to the ground, describing a grand spiral to the unrolling of the ropes. The difficult thing for these dancers is to seize this rope between their toes in such a way as to keep their heads down and arms outspread just like descending birds which soar in great circles in the sky. As for the chief, first he waits for some moments, then he lets himself glide along one of the four dancers' ropes.'
2
[Toton in the French text. M.B.]

contagion to which they surrender in instant compliance.[3]

Water rats divert themselves by spinning as if they were being drawn by an eddy in a stream. The case of the chamois is even more remarkable. According to Karl Groos, they ascend the glaciers, and with a leap, each in turn slides down a steep slope, while the other chamois watch.

The gibbon chooses a flexible branch and weighs it down until it unbends, thus projecting him into the air. He lands catch as catch can, and he endlessly repeats this useless exercise, inexplicable except in terms of its seductive quality. Birds especially love games of vertigo. They let themselves fall like stones from a great height, then open their wings when they are only a few feet from the ground, thus giving the impression that they are going to be crushed. In the mating season they utilize this heroic flight in order to attract the female. The American nighthawk, described by Audubon, is a virtuoso at these impressive acrobatics.[4]

Following the teetotum, *maïs d'or*, sliding, horsemanship, and swinging of their childhood, men surrender to the intoxication of many kinds of dance, from the common but insidious giddiness of the waltz to the many mad, tremendous and convulsive movements of other dances. They derive the same kind of pleasure from the intoxication stimulated by high speed on skis, motorcycles, or in driving sports cars. In order to give this kind of sensation the intensity and brutality capable of shocking adults, powerful machines have had to be invented. Thus it is not surprising that the Industrial Revolution had to take place before vertigo could really become a kind of game. It is now provided for the avid masses by thousands of stimulating contraptions installed at fairs and amusement parks.

These machines would obviously surpass their goals if it were only a question of assaulting the organs of the inner ear, upon which the sense of equilibrium is dependent. But it is the whole body which must submit to such treatment as anyone would fear undergoing, were it not that everybody else was seen struggling to do the same. In fact, it is worth watching people

3
Groos, op. cit. [Karl Groos, The Play of Animals (English translation: New York: D. Appleton & Co., 1898], p.208.
4
Ibid., p.259.

leaving these vertigo-inducing machines. The contraptions turn people pale and dizzy to the point of nausea. They shriek with fright, gasp for breath, and have the terrifying impression of visceral fear and shrinking as if to escape a horrible attack. Moreover the majority of them, before even recovering, are already hastening to the ticket booth in order to buy the right to again experience the same pleasurable torture.

It is necessary to use the word 'pleasure,' because one hesitates to call such a transport a mere distraction, corresponding as it does more to a spasm than an entertainment. In addition, it is important to note that the violence of the shock felt is such that the concessionaires try, in extreme cases, to lure the naive by offering free rides. They deceitfully announce that 'this time only' the ride is free, when this is the usual practice. To compensate, the spectators are made to pay for the privilege of calmly observing from a high balcony the terrors of the co-operating or surprised victims, exposed to fearful forces or strange caprices.

It would be rash to draw very precise conclusions on the subject of this curious and cruel assignment of roles. This last is not characteristic of a kind of game, such as is found in boxing, wrestling, and in gladiatorial combat. Essential is the pursuit of this special disorder or sudden panic, which defines the term vertigo, and in the true characteristics of the games associated with it: viz. the freedom to accept or refuse the experience, strict and fixed limits, and separation from the rest of reality. What the experience adds to the spectacle does not diminish but reinforces its character as play.

Translated by Meyer Barash

VII
The *Two Forms* of Soma

I now come to a crucial argument in my case.

The fly-agaric is unique among the psychotropic plants in one of its properties: it is an inebriant in *Two Forms*.

First Form:
Taken directly, and by 'directly' I mean by eating the raw mushroom, or by drinking its juice squeezed out and taken neat, or mixed with water, or with water and milk and curds, and perhaps barley in some form, and honey; also mixed with herbs such as Epilobium sp.

Second Form:
Taken in the urine of the person who has ingested the fly-agaric in the *First Form*.

The *Second Form*, as urine, was first called to the attention of the Western World by a Swedish army officer, Filip Johann von Strahlenberg, after having served 13 years as a captive of the Russians in Siberia. His book, first published in German in Stockholm, appeared in 1730;[1] and an English translation in London in 1736 and again in 1738 under a lengthy title beginning *An Historico-Geographical Description of the North and Eastern Parts of Europe and Asia*. Since then many other travellers and anthropologists have set forth the facts, usually going to extremes in characterizing the process as revolting, disgusting, filthy, and the like. So far as our records go, none of them has tried the urine, not even the anthropologists, among whom there are usually some who pride themselves on participating to the full in native ways and who consider it their professional duty to do so. In 1798, a Pole, Joseph Kopeć, a literary figure of some standing, tried the mushrooms (but not the urine) and published his remarkable impressions of the experience.[2] That he was ill at the time and running a fever detracts from the value of his testimony.

[1]
Philip Johan von Strahlenberg, Das Nord- und Östliche Theil von Europa und Asia, in so weit solcher das gantze Russische Reich mit Siberien und der grossen Tartary in sich begreiffet... Stockholm, 1730. Vide [3], p.234.

[2]
Vide [9], pp.243 ff

Plate i · THE SOMA OF THE ṚGVEDA

Plate ii · THE IMMORTAL HÁRI
RV IX 69⁵: With unfading vesture, brilliant, newly clothed, the immortal *hári*
wraps himself all around.

In the ṚgVeda Soma also has *Two Forms*, expressly so described in IX 66 [2, 3, 5]:

IX 66 [1-2]

> Cleanse thyself, O [thou] to whom all peoples belong, for all wondrous deeds, the praiseworthy god, the friend for the friends. With those two Forms [*dual, not plural*] which stand facing us, O Soma, thou reignest over all things, O Pávamāna!

> *pávasva viśvacarṣaṇe 'bhí víśvāni kǎvyā*
> *sákhā sákhibhya ī́ḍyaḥ*
> *tǎbhyāṃ víśvasya rājasi yé pavamāna dhǎmanī*
> *practī́cī́ soma tasthátuḥ*

IX 66 [3]

> The Forms [*plural, not dual*] that are thine, thou pervadest them, O Soma, through and through, O Pávamāna, at the appointed hours, O Wonder-worker!

> *pári dhǎmāni yǎni te tvǎṃ somāsi viśvátaḥ*
> *pávamāna ṛtúbhiḥ kave*

IX 66 [5]

> Thy shining rays spread a filtre on the back of heaven, O Soma, with [thy] Forms [*plural, not dual*]. [3]

> *táva śukrǎso arcáyo divás pṛṣṭhé ví tanvate*
> *pavítraṃ soma dhǎmabhiḥ*

In the Soma sacrifice the *First Form* is drunk by Indra and his charioteer, Vāyu, who are impersonated by high functionaries in the rite. The Vedic commentators, knowing nothing of the fly-agaric, have reached a consensus that the *First Form* is the simple juice of the Soma plant, and the *Second Form* is the juice after it has been mixed with water and with milk or curds. The commentators are agreed on this, the Vedic mythologies are so

3
Sanskrit and Vedic possess three numbers, singular, dual, and plural. In IX 66 [2] the dual number is used speaking of the *Two Forms*. This is natural as the poet faces two vessels containing, one the juice of Soma presumably mixed with milk, etc., the other Soma urine. In verses 3 and 5 he speaks of all Soma's forms, the celestial, the plant, the juice, the Soma urine, and therefore uses the plural.

written, the matter is considered settled.[4] While in default of
any other explanation it is easy to see how this was arrived at,
it is unsatisfactory because it flies in the faces of the ṚgVeda
text. Indra and Vāyu are repeatedly drinking the juice of Soma
mixed with milk or curds and, saving error on my part, they are
never in the ṚgVeda drinking juice expressly described as not
mixed with anything.

I will cite four instances where Indra and Vāyu drink
Soma mixed with milk or curds. The first instance, V 51 [4-7], is
crucial because there is no mention of curds and the reader
might think the poet was speaking of the unmixed juice,
exactly as the commentators contend, until suddenly in verse
7, just before the end, it seems that all along the poet took for
granted the curds! In the many instances where the poet does
not mention the milk or curds, the omission seems accidental.
The fly-agaric was often, perhaps usually, dried up when it was
used in the sacrifice, and initially it had to be soaked in water,
reinflated so to speak. Here are verses 51 [4-7]:

1

V 51 [4-7ab]

> ... Here is the Soma [that] pressed in the vat is poured
> all around inside the cup, he dear to Indra, to Vāyu.
> ... O Vāyu, arrive hither for the invitation, accepting
> it, to share in the oblation! Drink [of the juice] of the
> pressed stalk, up to [thy full] satisfaction!
> ... Indra and thou, Vāyu, ye have a right to drunk of
> these pressed [stalks]. Accept them, immaculate ones,
> for [your full] satisfaction!
> ... Pressed for Indra, for Vāyu, have been the soma
> plants requiring a mixture of curds.

4
Vide, e.g., A. A. Macdonell,
The Vedic Mythology,
London, 1897, pp. 82, 106.

ayáṃ sómaś camū sutó 'matre pári ṣicyate
priyá índrāya vāyáve
vāyav ā́ yāhi vītáye juṣānó havyádātaye
píbā sutásyāndhaso abhí práyaḥ
índraś ca vāyav eṣāṃ sutā́nāṃ pītím arhathaḥ
tā́ñ juṣethām arepásāv abhí prayaḥ
sutā́ índrāya vāyáve sómāso dádhyāśiraḥ

The following three quotations say expressly that Indra and
Vāyu drink Soma mixed with milk or curds:

2

IX 11 [2]

> The Atharvans have mixed milk with thy sweetness,
> longing for the god, the god [Soma] for the god [Indra].

IX 11 [5–6]

> Cleanse the Soma, pressed out by the hand-worked
> stones; dilute the sweet one in the sweetness [milk
> or water].
> Approach with reverence; mix him with curds, put the
> Soma juice into Indra.

> *abhí te mádhunā páyó 'tharvāṇo aśiśrayuḥ*
> *devám devā́ya devayú*
> *hástacyutebhir ádribhih sutáṃ sómaṃ punītana*
> *mádhāv ā́ dhāvatā mádhu*
> *námaséd úpa sīdata dadhnéd abhí śrīṇītana*
> *índum índre dadhātana*

3

IX 62 [5–6]

> The beautiful plant beloved of the gods, [the Soma]
> washed in the waters, pressed by the masters, the cows
> season [it] with milk.

Then like drivers [urging] on a horse, they have
beautified [the Soma], the juice of liquor for drinking
in common, for the Immortal One [Indra].

śubhrám ándho devávātam apsú dhūtó nṛbhih sutráḥ
svádanti gắvaḥ páyobhiḥ
ắd īm áśvaṃ ná hétāro śuśūbhann amṛtāya
mádhvo rásaṃ sadhamắde

4

IX 109 [15]

All the gods drink this Soma when it has been mixed
with milk of cows and pressed by the Officiants.

IX 109 [17–18]

The prize-winning Soma has flowed, in a thousand
drops cleansed by the waters, mixed with the milk
of cows.
O Soma, march ahead toward Indra's bellies, having
been held in hand by the Officiants, pressed by the
stones!

píbanty asya víśve devāso góbhiḥ śrītásya
nṛbiḥ sutásya
sá vājy ákṣāḥ sahásraretā adbhir mṛjānó
góbhiḥ śrīṇandḥ
prá soma yāhíndrasya kukṣắ nṛbhir yemānó
ádribhiḥ sutáḥ

If then the traditional view of the first and second
'Form' of Soma is to be replaced, what evidence do I adduce in
favor of my interpretation?
 Only the words of the Ṛg Veda. In the hymns to Soma
there comes a time when the religious emotion reaches a
climax, an intensity of exaltation, that is overwhelming, and
that after 3,000 years, in a world of utterly different orientation,

even in translation, cannot but move any perceptive reader,
These hymns are in Maṇḍala IX, from say 62 through perhaps
97, the mood then tending to ease off. The 74th hymn, in
particular, consists of an enumeration of phrases that we have
learned by now to recognize when they occur singly, clearly
numinous phrases for the contemporary believers, tense
phrases piled one on the other, Pelion on Ossa, in portentous
sequence, until we suddenly read, at the end of verse 4, a phrase
not met with before and not to be met again:

IX 74 [4]

> Soma, storm cloud imbued with life, is milked of ghee,
> milk. Navel of the Way, Immortal Principle, he sprang
> into life in the far distance. Acting in concert, those
> charged with the Office, richly gifted, do full honour
> to Soma. The swollen men piss the flowing [Soma].

> *ātmanván nábho duhyate ghṛtám páya ṛtásya nåbhir*
> *amŕtaṃ ví jāyate*
> *samīcīnåḥ sudånavaḥ prīṇanti tåṃ náro hitám áva*
> *mehanti péravaḥ*

If the final clause of this verse bears the meaning that I suggest
for it, then it alone suffices to prove my case.
 Renou render the final phrase of this verse 4 as follows:

> Les [Maruts] seigneurs à la vessie pleine compissent
> [le Soma] mis-en-branle.

> The [Maruts] lords with full bladders piss [Soma]
> quick with movement.

 Renou had lived with the ṚgVeda text for a lifetime and
knew everything that had ever been said by scholars about it.
He discerned that the 'swollen' men had full bladders and that
they were urinating Soma. But to give meaning to the sentence
he introduced the gods of rain, the Maruts. Certainly there are

precedents for the clouds' 'urinating' rain. But in this verse and at this point in the hymns the Maruts are out of place. From IX 68 to 109 there are 24 other citations of *nṛ* in the plural (men) and in every instance they are the officiants at the sacrifice.[5] So are they in 74[4]. It is noteworthy that Grassmann translates *nṛ* in this verse by 'men serving...' *etc.*, in conformity with his third definition of *nṛ*, 'men serving the gods, such as singers and sacrificers'. He does not translate it by his 6th definition, which would include gods. The priests appointed to impersonate Indra and Vāyu, having imbibed the Soma mixed with milk or curds, are now urinating Soma. They in their persons convert Soma into the *Second Form*. When Renou translated this verse, he had never heard of the Siberian use of the fly-agaric. Roger Heim and I apprised him of the facts when we dined with the Renous in the middle of April 1966.

Let us pause for a moment and dwell on a rather odd figure of speech. The blessings of the fertilizing rain are likened to a shower of urine. The storm-clouds fecundate the earth with their urine. Vedic scholars have lived so long with their recalcitrant text, and so close to it, that they remark no longer on an analogy that calls for explanation. Urine is normally something to cast away and turn from, second in this respect only to excrement. In the Vedic poets the values are reversed and urine is an ennobling metaphor to describe the rain. The values are reversed, I suggest, because the poets in Vedic India were thinking of urine as the carrier of the Divine Inebriant, the bearer of *amṛta*. This would explain the rôle that urine – human and bovine – has played through the centuries as the medico-religious disinfectant of the Indo-Iranian world, the Holy Water of the East.

The words of this hymn IX 74 are redolent with a most holy mystery, the handling of the miraculous Soma planted on the mountain tops by the gods. Those charged with the Office are the Guardians-of-the-Meaning, the Guardians-of-the-Melodies, the Guardians-of-the-Mystery. The Pressing Stones, the woolen Filtre, the mingling of the Soma juice first with water, then with milk or curds in the vessels – all this is

5
Vide IX 68[4, 7]; 72[2, 4, 5]; 73[3, 5]; 78[2]; 80[4(2)]; 86[20, 22, 34]; 87[1]; 91[2]; 95[1]; 97[5]; 99[8]; 101[3]; 107[16]; 108[15]; 109[8, 15, 18].

set forth clearly. Then the details of the Mystery are hidden
from us. This is not in my opinion deliberate. Every party to
the proceedings knew every detail. But when an event takes
place that stirs people to their depths, a hush naturally falls, a
feeling of awe and terror and adoration mingle. They speak in
a whisper, as the rubric directs the clergy to do at the climax
of the Mass. The details of the Mystery are certainly not to be
put into Hymns. Thus we do not know what the dose of the
juice was, nor how much water was added, nor how much milk
and curds, nor what the effect was. We do not know whether
the effect of the *First Form* and the *Second Form* was identical.
Chemists say it could well be different, the juice being one
thing and the metabolite another. Or it might be the same, the
juice developing its marvelous properties only after it has been
converted into the metabolite. There is a further possibility. In
modern experience the fly-agaric causes nausea. If the agent
that provokes vomiting is not the same as the one that leads to
ecstasy, the former might be eliminated in the digestive tract
and the urine be thus freed from this inconvenience. We do not
know how the metabolite was taken, whether neat or with water
or milk or curds or honey. In the RgVeda we are not told who
shared in the divine beverage. Afterwards only the priests, or
some of them, were privileged to imbibe, but must there not
have been a primitive age when others who participated in the
rites shared in the drink? We know that centuries later the
Śūdras, the outcastes, were not permitted even to hear the
words of the RgVeda hymns, so holy were these.

 Bhawe calls attention to three passages in the RgVeda
that seem to him to stress the skill needed in the mixing of
the Soma juice.[6] This might refer only to complicated
ritualistic gestures and postures that had to be executed
with precision. But in his judgement it is more likely that the
blending of the ingredients had to be just right. Perhaps there
was a secret recipe, the fruit of esoteric experience passed on
from one generation of priests to the next. This recipe might be
able to reduce or eliminate the initial nausea provoked by the
Soma juice.

6
S. S. Bhawe: *The Soma-Hymns of the RgVeda*, Part III, p. 176, comment on 70[8d]; also 47[1a] and 99[7a].

Let us pause for a moment and consider the probabilities. Some 3,250 years ago the Indo-Aryans living in the Indus Valley were worshipping a plant whose juice, pressed out and drunk immediately, seems to have had astonishing psychic effects, effects comparable to those of our Mexican hallucinogenic mushrooms, comparable but far different. The identity of that plant is not known. Hundreds of poets living over centuries in different centers speak of it in hallowed syllables but without mentioning leaves, roots, blossoms, or seed. Its stalk ('stipe' in mycologists' language) was obviously fleshy. How well these fit a wild mushroom! Nowhere in the thousand hymns is a dimension given of the 'stalk' that is incompatible with the stipe of a mushroom. It grew only high in the mountains. How well this fits the fly-agaric in the latitude of the Indus Valley! The poet says that the priests who have drunk the juice of this mysterious plant urinate the divine drink. In the traditions of Eurasia there is only one plant that supplies a psychotropic metabolite – the fly-agaric. Could any key unlock this combination save the fly-agaric?

If mine is indeed the interpretation to place on the *Second Form* of Soma in the RgVeda text, this should not be the only reference to the potable metabolite in Indo-Iranian literature and Parsi traditional practice. In the Avesta there is a verse in a famous Yasna, 48:10, supposed to preserve the very words of the Teacher himself, which has never been satisfactorily explained:

<u>When wilt thou do away with this urine of drunkenness</u> with which the priests evilly delude [the people] as do the wicked rulers of the provinces in [full] consciousness [of what they do]? [*Translation by R.C. Zaehner.* – The text below corresponds to the underlined part of the translation only.]

Kadā ajə̄n mūθrəm ahyā madahyā...?

The learned commentators, not knowing of the *Second Form* of the Soma of the Iranians (called Haoma), have arbitrarily

changed 'urine' to 'excrement' and have puzzled over the
meaning. Surely Zoroaster meant what he said: he was
excoriating the consumption of urine in the Soma sacrifice. If
my interpretation be accepted, there is opened up a promising
line of inquiry in Zoroastrian scholarship.

In the vast reaches of the *Mahābhārata*, the classical
Indian epic, there occurs one episode – an isolated episode
of unknown lineage – that bears with startling clarity on
our *Second Form*. It was introduced into the text perhaps a
thousand years after the fly-agaric had ceased to be used in
the Soma sacrifice, and perhaps the editor did not know its
meaning, which only today we are recovering. Here it is, as
translated by Wendy O'Flaherty.

Mahābhārata, Aśvamedha Parvan, 14.54.12-35

Kṛṣṇa had offered *Uttaṅka* a boon, and *Uttaṅka*
said, 'I wish to have water whenever I want it.' *Kṛṣṇa*
said, 'When you want anything, think on me,' and he
went away. Then one day *Uttaṅka* was thirsty, and he
thought on *Kṛṣṇa*, and thereupon he saw a naked, filthy
mātaṅga [= *caṇḍāla*, an outcaste hunter], surrounded
by a pack of dogs, terrifying, bearing a bow and arrows.
And *Uttaṅka* saw copious streams of water flowing
from his lower parts. The *mātaṅga* smiled and said to
Uttaṅka, 'Come, *Uttaṅka*, and accept this water from
me. I feel great pity for you, seeing you so overcome
by thirst.' The sage did not rejoice in that water, and
he reviled *Kṛṣṇa* with harsh words. The *mātaṅga* kept
repeating, 'Drink!', but the sage was angry and did
not drink. Then the hunter vanished with his dogs,
and *Uttaṅka*'s mind was troubled; he considered that
he had been deceived by *Kṛṣṇa*. Then *Kṛṣṇa* came,
bearing his disc and conch, and *Uttaṅka* said to him,
'It was not proper for you to give me such a thing,
water in the form of the stream from a *mātaṅga*.'
Then *Kṛṣṇa* spoke to *Uttaṅka* with honeyed words,

to console him, saying, 'I gave it to you in such form as was proper, but you did not recognize it. For your sake I said to Indra, "Give the *amṛta* to *Uttaṅka* in the form of water." Indra said to me, "A mortal should not become immortal; give some other boon to him." He kept repeating this, but I insisted, give the *amṛta*." Then he said to me, "If I must give it, I will become a *mātaṅga* and give the *amṛta* to the noble descendant of *Bhṛgu* [i.e., *Uttaṅka*]. If he accepts the *amṛta* thus, I will go and give it to him today." As he continued to say, "I will not give it [otherwise]," I agreed to this, and he approached you and offered the *amṛta*. But he took the form of a *caṇḍāla*. But your worth is great, and I will give you what you wished: on whatever days you have a desire for water, the clouds will be full of water then, and they will give water to you, and they will be called *Uttaṅka*-clouds.' Then the sage was pleased.

We found the first reference to Soma-urine in the ṚgVeda at a point in the liturgy where the proceedings and the religious emotion called for frankness in utterance. This reference did not stand alone in the literatures of Iran and India. There should be yet others in the ṚgVeda itself, perhaps more veiled as befits a holy mystery. I believe there are many such, but for the orderly progress of my argument I will defer their discussion until I reach the third of the three 'filtres'.

Shadows of the Mind:
A Search for the Missing Science
of Consciousness

92 93

Roger Penrose

Are clear-cut rules, like the principle of mathematical induction, always sufficient to establish the non-stopping nature of computations that in fact do not stop? The answer, surprisingly, is 'no'. This is one of the implications of Gödel's theorem, as we shall see shortly, and it will be important that we try to understand it. It is not just mathematical induction that is insufficient. *Any* set of rules *whatever* will be insufficient, if by a 'set of rules' we mean some system of formalized procedures for which it is possible to check entirely computationally, in any particular case, whether or not the rules have been correctly applied. This may seem a pessimistic conclusion, for it appears to imply that there are computations that never stop, yet the fact that they never stop cannot ever be rigorously mathematically ascertained. However, this is not at all what Gödel's theorem actually tells us. What it *does* tell us can be viewed in a much more positive light, namely that the insights that are available to human mathematicians – indeed, to anyone who can think logically with understanding and imagination – lie beyond anything that can be formalized as a set of rules. Rules can sometimes be a partial substitute for understanding, but they can never replace it entirely.

Families of Computations; the Gödel–Turing conclusion **G**

In order to see how Gödel's theorem (in the simplified form that I shall give, stimulated also by Turing's ideas) demonstrates this, we shall need a slight generalization on the kind of statements about computations that I have been considering. Instead of asking whether or not a single computation, such as **(A)**, **(B)**, **(C)**, **(D)**, or **(E)**, ever terminates, we shall need to consider a computation that depends on – or *acts* upon – *a natural number n*. Thus, if we call such a computation $C(n)$, we can think of this as providing us with a *family* of computations, where there is a separate computation for each natural number 0, 1, 2, 3, 4, ..., namely the computation $C(0)$, $C(1)$, $C(2)$, $C(3)$, $C(4)$, ..., respectively, and where the way in which the computation depends upon n is itself entirely computational.

In terms of Turing machines, all this means is that $C(n)$ is the action of some Turing machine on the number n. That is, the number n is fed in on the machine's tape as input, and the machine just computes on its own from then on. If you do not feel comfortable with the concept of a 'Turing machine', just think of an ordinary general-purpose computer, and regard n as merely providing the 'data' for the action of some programmed computer. What we are interested in is whether or not this computer action ever stops, for each choice of n.

In order to clarify what is meant by a computation depending on a natural number n, let us consider two examples:

(F) Find a number that is not the sum of n square numbers

and

(G) Find an odd number that is the sum of n even numbers.

It should be clear from what has been said above that the computation **(F)** will stop *only* when $n=0, 1, 2$, and 3 (finding the numbers 1, 2, 3, and 7, respectively, in these cases), and that **(G)** stops for no value of n whatever. If we are actually to ascertain that **(F)** does not stop when n is 4 or larger we require some formidable mathematics (Lagrange's proof); on the other hand, the fact that **(G)** does not stop for any n is obvious. What are the procedures that are available to mathematicians for ascertaining the non-stopping nature of such computations generally? Are these very procedures things that can be put into a computational form?

Suppose, then, that we have some computational procedure A which, when it terminates,[1] provides us with a demonstration that a computation such as $C(n)$ actually does not ever stop. We are going to try to imagine that A encapsulates *all* the procedures available to human mathematicians for convincingly demonstrating that computations do not stop. Accordingly, if in any particular case A itself ever comes to an end, this would provide us with a demonstration that the

particular computation that it refers to does *not* ever stop. For most of the following argument, it is necessary that A be viewed as having this particular role. We are just concerned with a bit of mathematical reasoning. But for our ultimate conclusion **G**, we are indeed trying to imagine that A has this status.

I am not requiring that A can always decide that $C(n)$ does not stop when in fact it does not, but I do insist that A does not ever give us wrong answers, i.e. that if it comes to the conclusion that $C(n)$ does not stop, then in fact it does not. If A does not in fact give us wrong answers, we say that A is *sound*.

It should be noted that if A were actually unsound, then it would be possible in principle to ascertain this fact by means of some direct calculation – i.e. an unsound A is computationally falsifiable. For if A were to assert erroneously that the computation $C(n)$ does not ever terminate when in fact it does, then the performing of the actual computation $C(n)$ would eventually lead to a refutation of A. (The issue of whether such a computation could ever be performed in practice is a separate matter [...])

In order for A to apply to computations generally, we shall need a way of coding all the different computations $C(n)$ so that A can use this coding for its action. All the different computations C can in fact be listed, say as

$$C_0, C_1, C_2, C_3, C_4, C_5, ...,$$

And we can refer to C_q as the qth computation. When such a computation is applied to a particular number n, we shall write

$$C_0(n), C_1(n), C_2(n), C_3(n), C_4(n), C_5(n), ...$$

We can take this ordering as being given, say as some kind of numerical ordering of computer programs. (To be explicit, we could, if desired, take this ordering as being provided by the Turing-machine numbering given in ENM [Roger Penrose, *The Emperor's New Mind*, Oxford 1990] so that then the computation $C_q(n)$ is the action of the qth Turing machine T_q

acting on n.) One technical thing that is important here is that this listing is *computable*, i.e. there is a single[2] computation C_\bullet that gives us C_q when it is presented with q, or, more precisely, the computation C_\bullet acts on the *pair* of numbers q, n (i.e. q followed by n) to give $C_q(n)$.

The procedure A can now be thought of as a particular computation that, when presented with the pair of numbers q, n, tries to ascertain that the computation $C_q(n)$ will never ultimately halt. Thus, when the computation A *terminates*, we shall have a demonstration that $C_q(n)$ *does not halt*. Although, as stated earlier, we are shortly going to imagine that A might be a formalization of *all* the procedures that are available to human mathematicians for validly deciding that computations never will halt, it is not at all necessary for us to think of A in this way just now. A is just *any sound* set of computational rules for ascertaining that some computations $C_q(n)$ do not ever halt. Being dependent upon the two numbers q and n, the computation that A performs can be written $A(q, n)$, and we have:

(H) If $A(q, n)$ stops, then $C_q(n)$ does not stop.

Now let us reconsider the particular statements **(H)** for which q is put equal to n. This may seem an odd thing to do, but it is perfectly legitimate. (This is often the first step in the powerful 'diagonal slash', a procedure discovered by the highly original and influential nineteenth-century Danish/Russian/German mathematician Georg Cantor, central to the arguments of both Gödel and Turing.) With q equal to n, we now have:

(I) If $A(n, n)$ stops, then $C_q(n)$ does not stop.

We now notice that $A(n, n)$ depends upon just one number n, not two, so it must be one of the computations $C_0, C_1, C_2, C_3, \ldots$ (as applied to n), since this was supposed to be a listing of all the computations that can be performed on a single natural number n. Let us suppose that it is in fact C_k, so

2
In fact this is achieved precisely by the action of a universal Turing machine on the pair of numbers q, n [...].

we have:

(J) $A(n, n) = C_k(n)$

Now examine the particular value $n = k$. (this is the second part of Cantor's diagonal slash!) We have, from **(J)**,

(K) $A(k, k) = C_k(k))$

and, from **(I)**, with $n = k$:

(L) If $A(k, k)$ stops, then $C_k(k)$ does not stop.

Substituting **(K)** in **(L)**, we find:

(M) If $C_k(k)$ stops, then $C_k(k)$ does not stop.

From this we must deduce that the computation $C_k(k)$ does *not* in fact stop. (For if it did then it does not, according to **(M)**!). But $A(k, k)$ cannot stop either, since by **(K)**, it is the *same* as $C_k(k)$. Thus, our procedure A is incapable of ascertaining that this particular computation $C_k(k)$ does not stop even though it does not.

Moreover, if we *know* that A is sound, then we know that $C_k(k)$ does not stop. Thus, we know something that A is unable to ascertain. It follows that A *cannot* encapsulate our understanding.

At this point, the cautious reader might wish to read over the whole argument again, as presented above, just to make sure that I have not indulged in any 'sleight of hand'! Admittedly there is an air of the conjuring trick about the argument, but it is perfectly legitimate, and it only gains in strength the more minutely it is examined. We have found a computation $C_k(k)$ that we know does not stop; yet the given computational procedure A is not powerful enough to ascertain that fact. This is the Gödel(–Turing) theorem in the form that I require. It applies to any computational procedure

A whatever for ascertaining that computations do not stop, *so long as we know it to be sound.* We deduce that no knowably sound set of computational rules (such as A) can ever suffice for ascertaining that computations do not stop, since there are some non-stopping computations (such as $C_k(k)$) that must elude these rules. Moreover, since from the knowledge of A and of its soundness, we can actually construct a computation $C_k(k)$ that we can *see* does not ever stop, we deduce that A *cannot* be a formalization of the procedures available to mathematicians for ascertaining that computations do not stop, no matter what A is. Hence:

G Human mathematicians are not using a knowably sound algorithm in order to ascertain mathematical truth.

It seems to me that this conclusion is inescapable. However, many people have tried to argue against it [...] and certainly many would argue that the stronger deduction that there must be something fundamentally non-computational in our thought processes. The reader may indeed wonder what on earth mathematical reasoning like this, concerning the abstract nature of computations, can have to say about the workings of the human mind. What, after all, does any of this have to do with the issue of conscious awareness? The answer is that the argument indeed says something very significant about the mental quality of *understanding* – in relation to the general issue of computation – and [...] the quality of understanding is something dependent upon conscious awareness. It is true that, for the most part, the foregoing reasoning has been presented as just a piece of mathematics, but there is the essential point that the algorithm A enters the argument at two quite different levels. At the one level, it is being treated as just some algorithm that has certain properties, but at the other, we attempt to regard A as being *actually* 'the algorithm that we ourselves use' in coming to believe that a computation will not stop. The argument is *not* simply about computations. It is also about how we use our conscious understanding in order to infer the

validity of some mathematical claim – here the non-stopping character of $C_k(k)$. It is the interplay between the two different levels at which the algorithm A is being considered – as a putative instance of conscious activity and as a computation itself – that allows us to arrive at a conclusion expressing a fundamental conflict between such conscious activity and mere computation.

However, there are indeed various possible loopholes and counter-arguments that must be considered. First, in the remainder of this chapter, I shall go very carefully through *all* the relevant counter-arguments against the conclusion **G** that have come to my attention [...]. Each of these will be answered as carefully as I am able. We shall see that the conclusion **G** comes through essentially unscathed. Then, in Chapter 3, I shall consider the implications of **G** itself. We shall find that it indeed provides the basis for a very powerful case that conscious mathematical understanding cannot be properly modelled *at all* in computational terms, whether top-down or bottom-up or any combination of the two. Many people might find this to be an alarming conclusion, as it may seem to have left us with nowhere to turn. In Part II of this book I shall take a more positive line. I shall make what I believe to be a plausible scientific case for my own speculations about the physical processes that might conceivably underlie brain action, such as when we follow through an argument of this kind, and how this might indeed elude any computational description.

Drawings
Photographs
Images

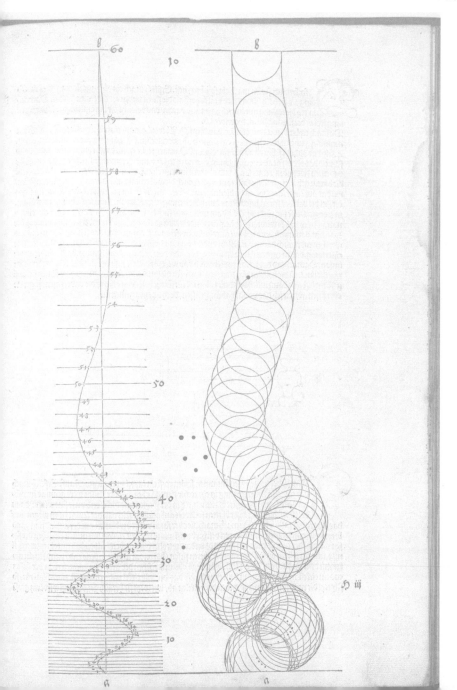

貝の見分け方

トリガイ 殻長：9cm

蒲江（大分県）

　『大分県海産貝類仮目録』九州貝類談話会大
分県会員，1978）は全県下に産する海産の貝
1584種が収録されている。蒲江沖，深島，屋形島
産の貝が目立つ。
　『大分県陸産貝類誌』（神田正人，1992）には
140種収録されている。

ミミズガイ
殻高：7cm

マガキガイ
殻高：6cm

キヌガサガイ　殻幅：10cm

ホンクマサカ
殻幅：4cm

ヒメツメタ
殻高：4cm

ククリボラ
殻高：4cm

イセカセン
殻高：4cm

オオツキガイモドキ
殻長：6cm

ビノスモドキ　殻長：10cm

袴腰（鹿児島県・桜島）

　『鹿児島湾産貝類仮目録』（坂下泰典，198
には鹿児島湾沿岸のほか，山川沖（湾入り口），
島（燃島）の貝1539種が収録されている。
　鹿児島市近郊の好採集地に袴腰海岸があ
桜島の大噴火によって流れ出た溶岩の転石地
である。石の上にはイシダタミ，シマレイシダマ
レイダマシモドキ，クリフレイシなど，石をおこすと
ガイ，トマヤガイ，ウシヒザラガイ，ケムシヒザラガ
スガイ，コシダカサザエなどが採れる。

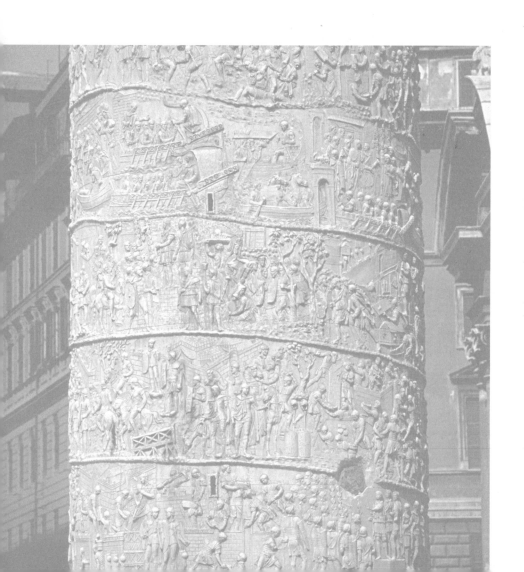

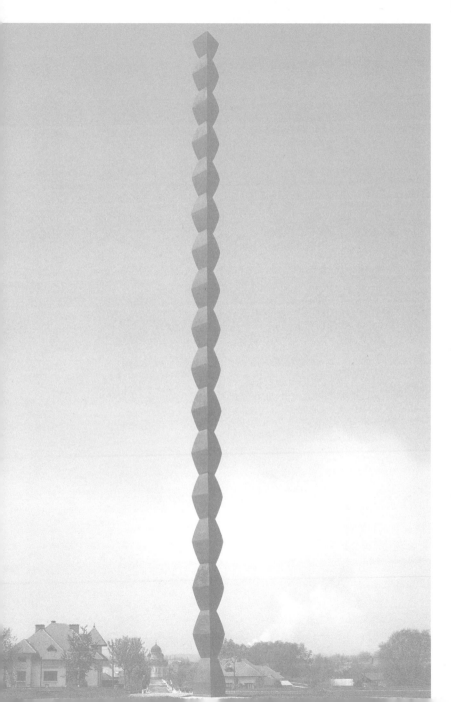

FIG. 116 [632]. Pyramid (× 110).

FIG. 117 [659]. Degenerate column (× 48).

FIG. 118 [660]. Degenerate column (× 95).

FIG. 119 [633]. Column in complete form.

FIG. 120 [654]. Transition from cup to column (× 58).

a) b) c)

FIG. 121. Sketches of cup and column.

52

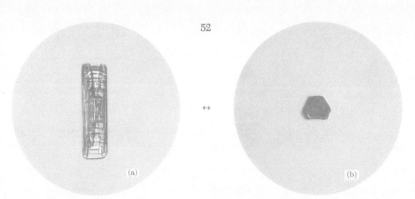

↔

FIG. 122. Column with one side rolled up: (*a*) [637] side view; (*b*) [638] end view (× 35).

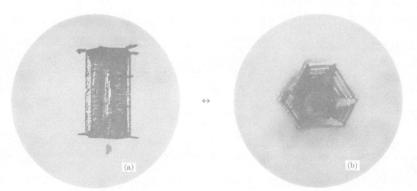

↔

FIG. 123. Column showing skeleton structure: (*a*) [647] side view (× 39); (*b*) [648] end view (× 54).

FIG. 124 [649]. Slender column (× 42).

FIG. 125 [658]. Short column (× 54).

Fig. 87 [494]. Malformed crystal of four-branched type (× 65).

Fig. 88 [488]. Malformed crystal of type of 68(e), before separation (× 26).

Fig. 89 [487]. A crystal similar to that of Fig. 88, after separation (× 19).

Fig. 90 [500]. Malformed crystal of three-branched type (× 43).

Fig. 91 [523]. Components developing in different planes.

Fig. 92 [436]. Overlapping of several planes (× 21).

43

Fig. 93 [437]. Overlapping of several planes (× 19.5).

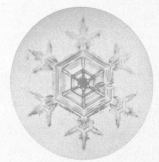

Fig. 94 [531]. Malformed plate (× 28).

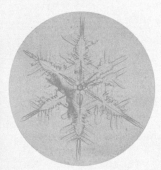

Fig. 95 [534]. Malformed plate with dendritic extensions (× 23).

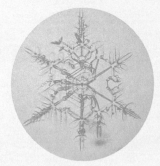

Fig. 96 [535]. Malformed plate with dendritic extensions (× 24.5).

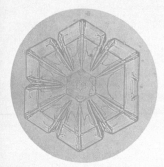

Fig. 97 [542]. Malformed sectors (× 57).

Fig. 98 [547]. Malformed crystal of two-branched type (× 50).

List of Illustrations and Sources

Illustrations

pp.103, 105: From Jean Larcher, _Optical and Geometrical Allover Patterns: 70 Original Drawings_, Dover Publications, New York 1979

p.107: Diagram of optical rectifications for a twisted column, in Albrecht Dürer, _Die Unterweysung der Messung_, Nuremberg 1525

p.109: From _Rabindranath Tagore: Santiniketan, Sriniketan (An Introduction)_ (anonymous and undated pamphlet)

pp.110–11: Winsor McCay, _Little Nemo in Slumberland_. p.110: drawing for newspaper Sunday page, published 2 February 1908, Ohio State University Cartoon Research Library, Woody Gelman Collection; p.111: newspaper Sunday page, published 1 March 1908, collection of Peter Maresca

p.113: Optical illusion known as 'Fraser's Spiral', first published in James Fraser, 'A New Visual Illusion of Direction', _British Journal of Psychology_, 1908

p.115: Johann Heinrich Glaser, anamorphic image of _A Woman and a Madman_, 17th century, oil on panel with tube, Historisches Museum Basel

p.116: From Yoshizou Yukita, _Kai No Zukan: Shuushuu and Hyouhon No Tukurikata_ (An illustrated book of shellfish: how to do a collection and make specimens), Nanpoushinsha, Kagoshima City 2003

119: Detail of Trajan's Column 113 AD, Rome

p.121: Constantin Brancusi, _The Endless Column_ 1938, Tirgu Jiu, Romania ©ADAGP, Paris and DACS, London 2006

pp.122–5: From Ukicho Nakaya, _Snow Crystals: Natural and Artificial_, Cambridge, Mass. 1954 © 1954 by the President and Fellows of Harvard College

p.127: Margaret Bourke-White, _Machine Dance, Moscow Ballet School_ 1931. © Margaret Bourke-White. Courtesy Corkin Shopland Gallery, Toronto

Illustrations: Photo Credits

p.107: © Germanisches National Museum, Nürnberg; p.110: © 2006 Peter Maresca; p.111: © Ron Hughes, Slide Service International; p.115: © M. Babey/Historisches Museum Basel; p.119: © The Bridgeman Art Library; p.121: © Adam Woolfitt/CORBIS

Sources

The texts are presented as originally published, except that notes have been renumbered to avoid any confusion. The publishers either have sought or are grateful to the following for permission to reproduce material.

H.G.Wells, 'The New Accelerator'. Reprinted by permission of AP Watt Ltd on behalf of The Literary Executors of the Estate of H.G.Wells. Published in _Twelve Stories and a Dream_, Macmillan & Co., Ltd, London/The Macmillan Co., New York 1903

Excerpt from Henri Michaux, _Face aux verrous_, © 1954 by Librairie Gallimard, Paris. Translation by David Ball © Tate 2006

Excerpt from Henri Bergson, _The Two Sources of Morality and Religion_, translated by R. Ashley Audra and Cloudesley Brereton with the assistance of W. Horsfall Carter. Copyright © 1935 by Henry Holt & Co., Inc.; copyright renewed © 1963 by Holt, Rinehart and Winston. Used with permission of University of Notre Dame Press

Excerpt from Stephen Jay Gould, _The Panda's Thumb: More Reflections in Natural History_, copyright © 1980 by Stephen Jay Gould. Used with permission of W.W. Norton & Company Inc.

René Daumal, _A Fundamental Experiment_ (1944), translated by Roger Shattuck, translation © 1959, 1987 by Roger Shattuck

Excerpt from interview with Paolo Fabbri by Hans Ulrich Obrist with questions by Dominique Gonzalez-Foerster and Philippe Parreno, first published as an online posting on nettime

Excerpt from Juan Carlos Gomez, 'Mutual Awareness in Primate Communication: A Gricean Approach', in S. Taylor Parker, R.W. Mitchell and M.L. Boccia (eds.) _Self-awareness in Animals and Humans: Developmental Perspectives_, Cambridge University Press 1994. Copyright © Cambridge University Press 1994

Excerpt from Roger Caillois, _Man, Play and Games_, © 1958 by Librairie Gallimard, Paris. English translation © 1961 by The Free Press of Glencoe, Inc. Used with permission of the University of Illinois Press

Excerpt from R. Gordon Wasson, _Soma: Divine Mushroom of Immortality_, Harcourt Brace Jovanovich, Inc., New York 1968. Copyright © 1968 by R. Gordon Wasson

Excerpt from Roger Penrose, _The Shadows of the Mind: A Search for the Missing Science of Consciousness_, Oxford University Press 1994. Copyright © 1994 by Roger Penrose